KAWAII: HOW TO DRAW REALLY CUTE FOOD

Angela Nguyen

This edition published in 2019 by

Search Press Ltd

Wellwood

North Farm Road

Tunbridge Wells

Kent TN2 3DR

United Kingdom

Reprinted 2020, 2021, 2022

Copyright © 2019 Quarto Publishing plc An imprint of The Quarto Group ISBN 978-1-78221-808-1

All rights reserved. No part of this book may be reproduced in any form or by any means, electronic or mechanical, including photocopying, recording, or by any information storage and retrieval system, without permission in writing from the publisher.

Conceived, edited and designed by

Quarto Publishing plc

The Old Brewery

6 Blundell Street

London N7 9BH

www.quartoknows.com

QUAR.325421

Editor: Claire Waite Brown

Designer: Karin Skånberg

Deputy Art Director: Martina Calvio

Publisher: Samantha Warrington

Printed in China

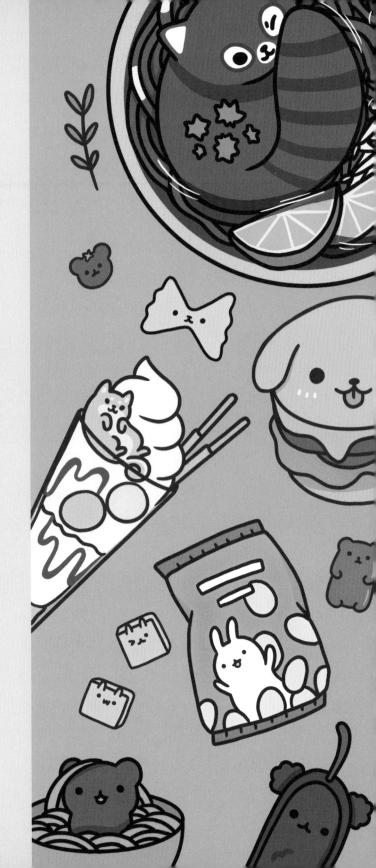

CONTENTS

TACOS AND BURRITOS 62				
Chapter one GETTING STARTED 8	ANGELA'S WORLD	6	TACOS AND BURRITOS	62
Chapter one GETTING STARTED 8			RICE	64
SANDWICHES 70			SOUPS	66
HOTPOTS 72			FINE DINING	68
EGGS	GETTING STARTED 8		SANDWICHES	70
TOOLS AND SURFACES			HOTPOTS	72
BASICS OF FOOD ANIMALS 12 BREAKFAST FOODS 78			EGGS	74
## SUSHI 80 ## BRING YOUR DRAWINGS TO LIFE 16 PIZZA 82 Chapter two		10	NOODLES	76
Chapter two Chapter four DESSERTS AND SWEET TREATS 84			BREAKFAST FOODS	78
Chapter two SNACKS AND APPETIZERS 18	BASICS OF CUTENESS	14	SUSHI	80
DESSERTS AND SWEET TREATS 84	BRING YOUR DRAWINGS TO LIFE	16	PIZZA	82
DESSERTS AND SWEET TREATS 84	Chapter two		Chapter Lour	
CRISPS AND SNACKS 22 DOUGHNUTS 88 HOT DOGS 24 PASTRIES 90 TORTILLA CHIPS 26 PARFAIT 92 STEAMED BUNS 28 CUPCAKES 94 BREAD 30 CREPES 96 CHEESE SELECTION 32 CHOCOLATE 98 CHIPS AND WEDGES 34 SWEETS 100 WRAPPED APPETIZERS 36 BISCUITS 102 SKEWERS 38 ICE CREAM 104 LEAF WRAPPINGS 40 MACARONS 106 SALADS 42 PIES 108 CHOWDER 44 CARAMEL PUDDINGS 110 PLATTERS 46 FRUIT DESSERTS 112 SWEETCORN 48 STUFFED VEGETABLES 50 Chapter five CUTE DRINKS 114 CHAPTER SET MILKSHAKES 116 TEA 118 HAMBURGERS 54 FIZZY DRINKS 120 CUTE DRINKS 120 CUTE DRIN				
CRISPS AND SNACKS 22 DOUGHNUTS 88 HOT DOGS 24 PASTRIES 90 TORTILLA CHIPS 26 PARFAIT 92 STEAMED BUNS 28 CUPCAKES 94 BREAD 30 CREPES 96 CHEESE SELECTION 32 CHOCOLATE 98 CHIPS AND WEDGES 34 SWEETS 100 WRAPPED APPETIZERS 36 BISCUITS 102 SKEWERS 38 ICE CREAM 104 LEAF WRAPPINGS 40 MACARONS 106 SALADS 42 PIES 108 CHOWDER 44 CARAMEL PUDDINGS 110 PLATTERS 46 FRUIT DESSERTS 112 SWEETCORN 48 STUFFED VEGETABLES 50 Chapter five CUTE DRINKS 114 CHAPTER SET MILKSHAKES 116 TEA 118 HAMBURGERS 54 FIZZY DRINKS 120 CUTE DRINKS 120 CUTE DRIN				
## PASTRIES 90 TORTILLA CHIPS 26 PARFAIT 92 STEAMED BUNS 28 CUPCAKES 94 BREAD 30 CREPES 96 CHEESE SELECTION 32 CHOCOLATE 98 CHIPS AND WEDGES 34 SWEETS 100 WRAPPED APPETIZERS 36 BISCUITS 102 SKEWERS 38 ICE CREAM 104 LEAF WRAPPINGS 40 MACARONS 106 SALADS 42 PIES 108 CHOWDER 44 CARAMEL PUDDINGS 110 PLATTERS 46 FRUIT DESSERTS 112 SWEETCORN 48 STUFFED VEGETABLES 50 Chapter five CUTE DRINKS 114 CHAPTER S 54 FIZZY DRINKS 120 CURRY 56 JUICE 122 STONE POTS 58 COFFEE 124	POPCORN	20	CAKES	86
## PASTRIES 90 TORTILLA CHIPS 26 PARFAIT 92 STEAMED BUNS 28 CUPCAKES 94 BREAD 30 CREPES 96 CHEESE SELECTION 32 CHOCOLATE 98 CHIPS AND WEDGES 34 SWEETS 100 WRAPPED APPETIZERS 36 BISCUITS 102 SKEWERS 38 ICE CREAM 104 LEAF WRAPPINGS 40 MACARONS 106 SALADS 42 PIES 108 CHOWDER 44 CARAMEL PUDDINGS 110 PLATTERS 46 FRUIT DESSERTS 112 SWEETCORN 48 STUFFED VEGETABLES 50 Chapter five CUTE DRINKS 114 CHAPTER S 54 FIZZY DRINKS 120 CURRY 56 JUICE 122 STONE POTS 58 COFFEE 124	CRISPS AND SNACKS	22	DOUGHNUTS	88
STEAMED BUNS 28	HOT DOGS	24	PASTRIES	90
BREAD	TORTILLA CHIPS	26	PARFAIT	92
CHEESE SELECTION 32 CHOCOLATE 98 CHIPS AND WEDGES 34 SWEETS 100 WRAPPED APPETIZERS 36 BISCUITS 102 SKEWERS 38 ICE CREAM 104 LEAF WRAPPINGS 40 MACARONS 106 SALADS 42 PIES 108 CHOWDER 44 CARAMEL PUDDINGS 110 PLATTERS 46 FRUIT DESSERTS 112 SWEETCORN 48 STUFFED VEGETABLES 50 Chapter five CUTE DRINKS 114 Cute Drinks 114 Chapter five CUTE DRINKS 114 TEA 118 HAMBURGERS 54 FIZZY DRINKS 120 CURRY 56 JUICE 122 STONE POTS 58 COFFEE 124	STEAMED BUNS	28	CUPCAKES	94
CHIPS AND WEDGES 34 SWEETS 100 WRAPPED APPETIZERS 36 BISCUITS 102 SKEWERS 38 ICE CREAM 104 LEAF WRAPPINGS 40 MACARONS 106 SALADS 42 PIES 108 CHOWDER 44 CARAMEL PUDDINGS 110 PLATTERS 46 FRUIT DESSERTS 112 SWEETCORN 48 STUFFED VEGETABLES 50 Chapter three ENTRÉES 52 MILKSHAKES 116 TEA 118 HAMBURGERS 54 FIZZY DRINKS 120 CURRY 56 JUICE 122 STONE POTS 58 COFFEE 124	BREAD	30	CREPES	96
WRAPPED APPETIZERS 36 BISCUITS 102 SKEWERS 38 ICE CREAM 104 LEAF WRAPPINGS 40 MACARONS 106 SALADS 42 PIES 108 CHOWDER 44 CARAMEL PUDDINGS 110 PLATTERS 46 FRUIT DESSERTS 112 SWEETCORN 48 STUFFED VEGETABLES 50 Chapter five CUTE DRINKS 114 Chapter five CUTE DRINKS 114 TEA 118 HAMBURGERS 54 FIZZY DRINKS 120 CURRY 56 JUICE 122 STONE POTS 58 COFFEE 124	CHEESE SELECTION	32	CHOCOLATE	98
WRAPPED APPETIZERS 36 BISCUITS 102 SKEWERS 38 ICE CREAM 104 LEAF WRAPPINGS 40 MACARONS 106 SALADS 42 PIES 108 CHOWDER 44 CARAMEL PUDDINGS 110 PLATTERS 46 FRUIT DESSERTS 112 SWEETCORN 48 TEA Chapter live CUTE DRINKS 114 Chapter live CUTE DRINKS 114 TEA 118 HAMBURGERS 54 FIZZY DRINKS 120 CURRY 56 JUICE 122 STONE POTS 58 COFFEE 124	CHIPS AND WEDGES	34	SWEETS	100
LEAF WRAPPINGS		36	BISCUITS	102
SALADS 42 PIES 108 CHOWDER 44 CARAMEL PUDDINGS 110 PLATTERS 46 FRUIT DESSERTS 112 SWEETCORN 48 STUFFED VEGETABLES 50 Chapter five CUTE DRINKS 114 CUTE DRINKS 114 MILKSHAKES 116 TEA 118 HAMBURGERS 54 FIZZY DRINKS 120 CURRY 56 JUICE 122 STONE POTS 58 COFFEE 124	SKEWERS	38	ICE CREAM	104
SALADS 42 PIES 108 CHOWDER 44 CARAMEL PUDDINGS 110 PLATTERS 46 FRUIT DESSERTS 112 SWEETCORN 48 STUFFED VEGETABLES 50 Chapter five CUTE DRINKS 114 CUTE DRINKS 114 MILKSHAKES 116 TEA 118 HAMBURGERS 54 FIZZY DRINKS 120 CURRY 56 JUICE 122 STONE POTS 58 COFFEE 124	LEAF WRAPPINGS	40		106
PLATTERS SWEETCORN STUFFED VEGETABLES Chapter three ENTRÉES 52 MILKSHAKES TEA 118 HAMBURGERS CURRY 56 JUICE 122 STONE POTS FRUIT DESSERTS 112 Chapter five CUTE DRINKS 114 COUTE DRINKS 116 TEA 118 118 120 121 122 122 124	SALADS	42		108
PLATTERS SWEETCORN STUFFED VEGETABLES Chapter three ENTRÉES 52 MILKSHAKES TEA 118 HAMBURGERS CURRY 56 JUICE 122 STONE POTS FRUIT DESSERTS 112 Chapter five CUTE DRINKS 114 COUTE DRINKS 116 TEA 118 118 120 121 122 122 124	CHOWDER	44	CARAMEL PUDDINGS	110
Chapter live Chapter three ENTRÉES 52 MILKSHAKES 116 TEA 118 HAMBURGERS CURRY 56 JUICE 122 STONE POTS Chapter live CUTE DRINKS 114	PLATTERS	46		112
Chapter three ENTRÉES 52 MILKSHAKES 116 TEA 118 HAMBURGERS 54 FIZZY DRINKS 120 CURRY 56 JUICE 122 STONE POTS 58 COFFEE 124	SWEETCORN	48		
CHAPTER three ENTRÉES 52 MILKSHAKES 116 TEA 118 HAMBURGERS CURRY 56 JUICE 122 STONE POTS 58 CUTE DRINKS 114				
Chapter three ENTRÉES 52 MILKSHAKES 116 TEA 118 HAMBURGERS 54 FIZZY DRINKS 120 CURRY 56 JUICE 122 STONE POTS 58 COFFEE 124				
ENTRÉES 52 MILKSHAKES 116 TEA 118 HAMBURGERS 54 FIZZY DRINKS 120 CURRY 56 JUICE 122 STONE POTS 58 COFFEE 124	Chapter three		CUTE DRINKS	114
TEA 118 HAMBURGERS 54 FIZZY DRINKS 120 CURRY 56 JUICE 122 STONE POTS 58 COFFEE 124				
HAMBURGERS 54 FIZZY DRINKS 120 CURRY 56 JUICE 122 STONE POTS 58 COFFEE 124			MILKSHAKES	116
CURRY 56 JUICE 122 STONE POTS 58 COFFEE 124			TEA	118
STONE POTS 58 COFFEE 124	HAMBURGERS	54	FIZZY DRINKS	120
	CURRY	56	JUICE	122
PASTA 60 FANCY DRINKS 126	STONE POTS	58	COFFEE	124
	PASTA	60	FANCY DRINKS	126

CREDITS

128

ANGELA'S WORLD

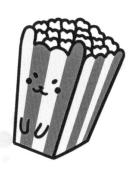

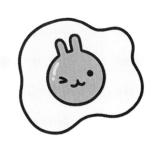

Hi there, my name is Angela! I'm an artist who specializes in drawing cute things, especially animals and food. Anything small, round or fluffy is my basic formula for drawing cute stuff.

For as long as I can remember, I've had the urge to draw cute things. There's just something about cuteness that never ceases to brighten a person's day.

I want to walk you through how to draw cute animals and food so that you too can brighten other people's days.

Animals and food (especially) are all around us, so there will be plenty of inspiration throughout your life for reference. Follow along with my drawing journey to create cute animal-food fusions of your own.

Angela Nguyen

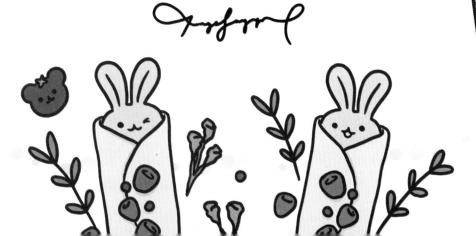

Chapter one

GETTING STARTED

You don't need special tools or materials to draw cute food. Experiment with pens, pencils and surfaces and learn how to give your drawings cute appeal!

TOOLS AND SURFACES

There are many types of tools you can use to draw and colour cute animal-food fusions. These are some of the tools that I love to use.

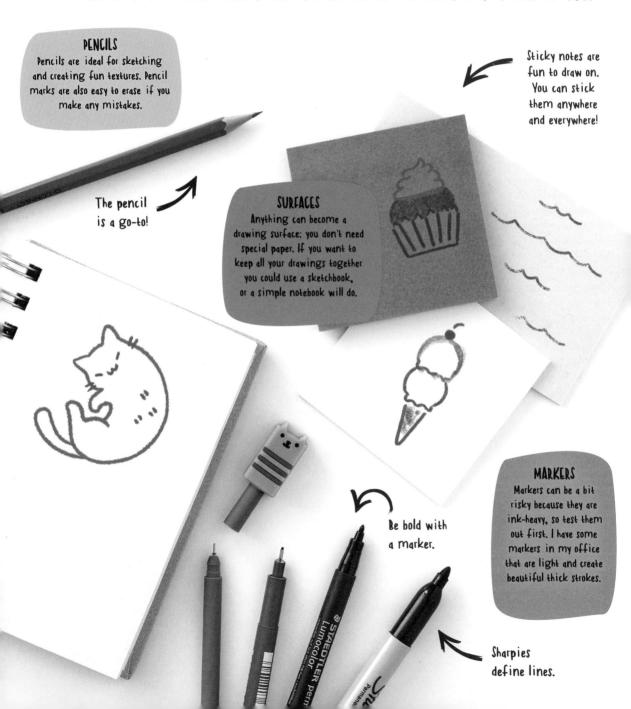

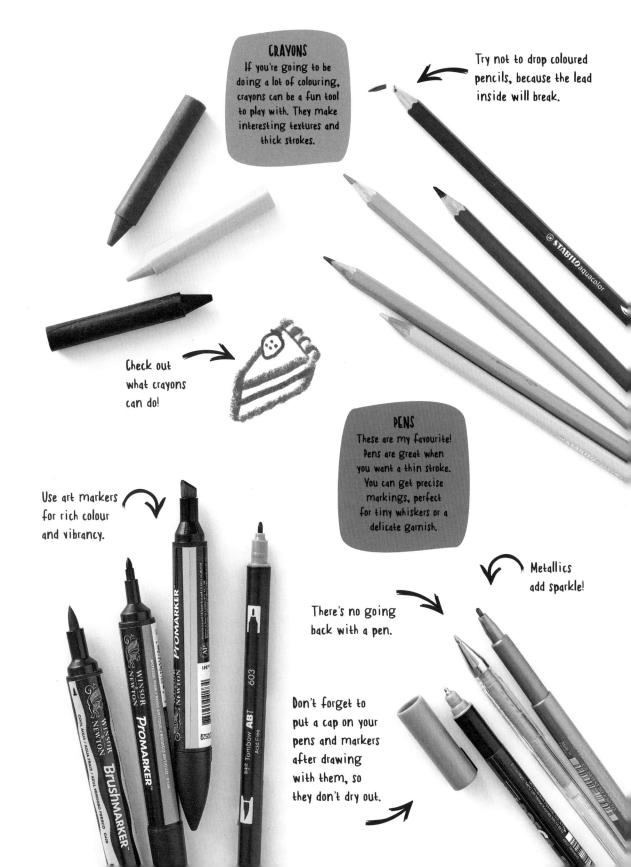

BASICS OF FOOD ANIMALS

There are lots of ways to draw food animals. Here are some ideas to get you started.

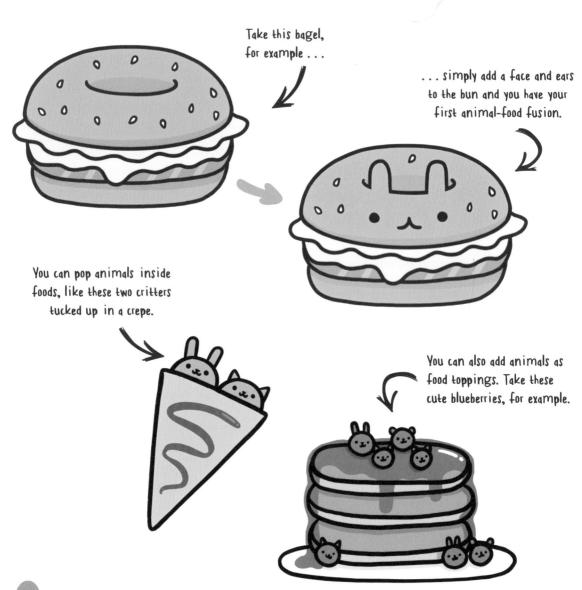

ANIMAL EARS

Simply changing the shape of the ears can be key to mixing up your food-animal creations. Cats have triangle ears. Dog ears are more floppy. Bunny ears are longer and bears have little round ears.

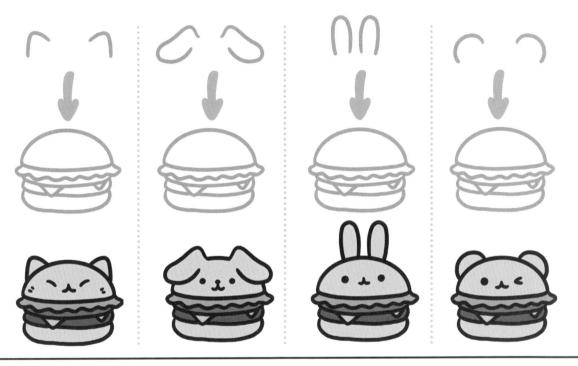

As you become more accomplished with the basic principles, try something more advanced, such as drawing a whole animal, using its body as the food.

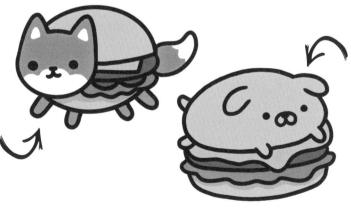

Another trick is to turn only half of the food into an animal. Here I've made just the bun into a dog.

BASICS OF CUTENESS

You can adapt these simple steps when drawing any food animal.

STEP 1: THE BASE

Most animals will be made of a few simple shapes. Start by making the base with only shapes, like two circles for the face and body. Adding the ears helps to define the animal.

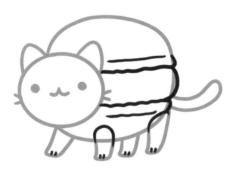

STEP 3: DETAILS

Add the details to your animal and the food.

This includes extra lines, textures or other
features you want to show off.

STEP 2: LIMBS

Limbs are fun! They stick out of the body in whichever direction you choose. Depending on the animal, you can make them long or short. The facial features are really easy, just a few dots and lines and your animal comes to life.

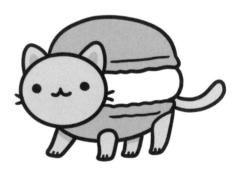

STEP 4: COLOURING

finally, finish off your drawing with pastel colours. Light colours will make your food animal look super cute.

THREE RULES FOR CUTE APPEAL

RULE 1: SIMPLIFY

By focusing less on the details, you can concentrate on the cuteness! Use fewer lines and simple, round strokes.

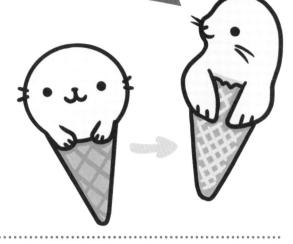

RULE 2: LIGHT COLOURS

Use pastel colours to lighten your drawings. Intense, dark or dull colours will make your drawing look too serious (unless that's what you're going for!).

RULE 3: ROUNDNESS

Round shapes like circles and curves ease the eye. They make your drawing look friendly. Look how chubby and cuddly these cute gummy bears are.

BRING YOUR DRAWINGS TO LIFE

You can bring your food animal to life with a few extra pen strokes.

SHOW MOTION

Action lines are special effects you can add alongside your food animals to animate them.

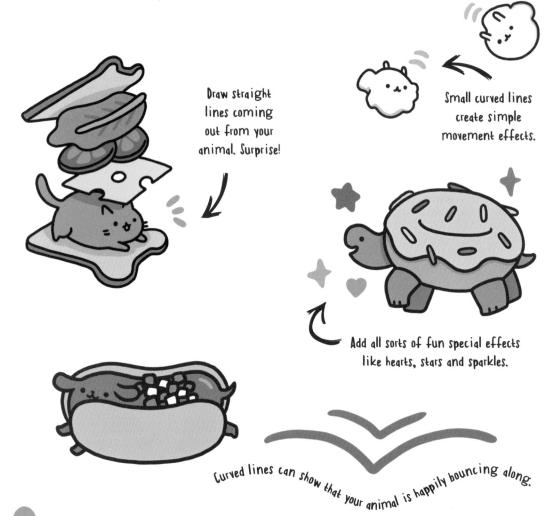

SHOW EMOTION

Change the shape of the eyes, eyebrows and mouth to show how your animal is feeling. Here are some ideas for you.

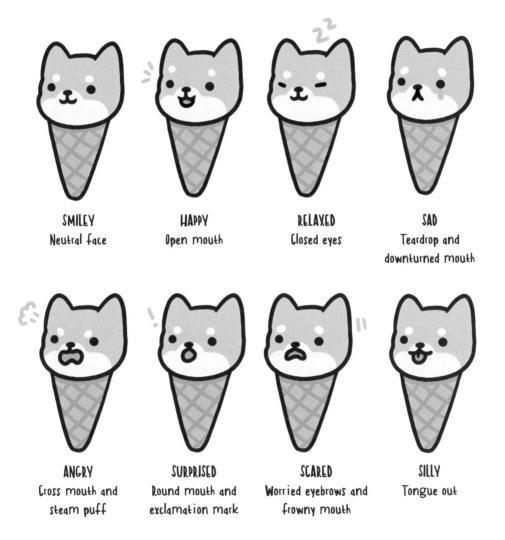

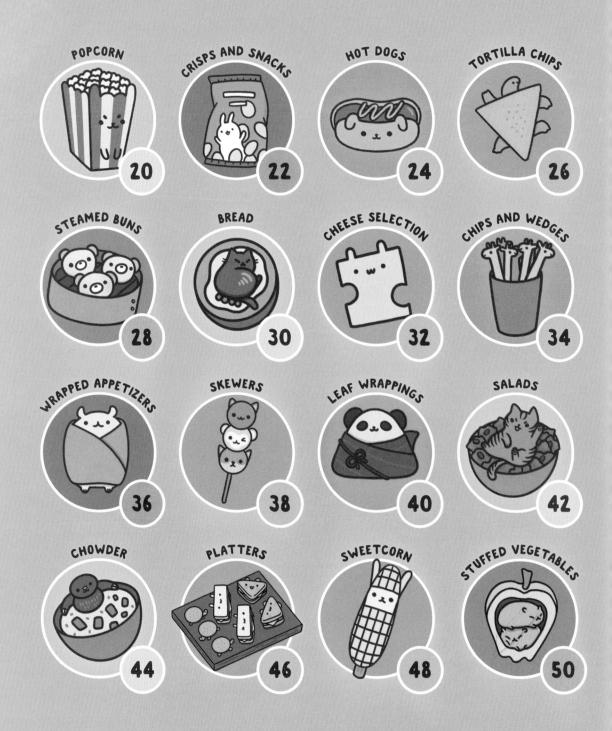

Chapter two

SNACKS AND APPETIZERS

In this chapter you might find cute animals swimming around in your soup or wrapped up in a cosy tortilla.

Movie popcorn

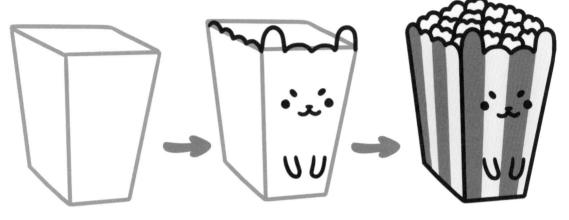

This is a typical popcorn pack you might buy at the cinema. The base is a tall box. Draw on the face, ears and limbs of your animal.

Then add in the striped colours and popcorn filling.

Lunch box popcorn

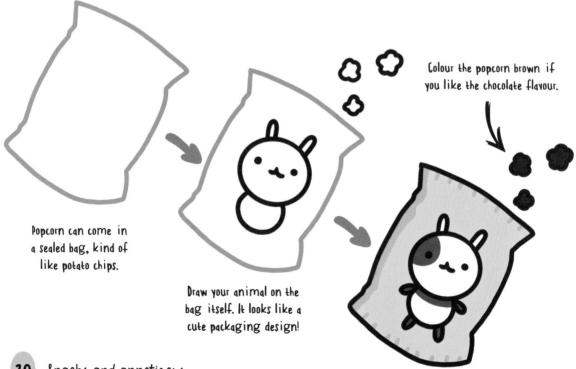

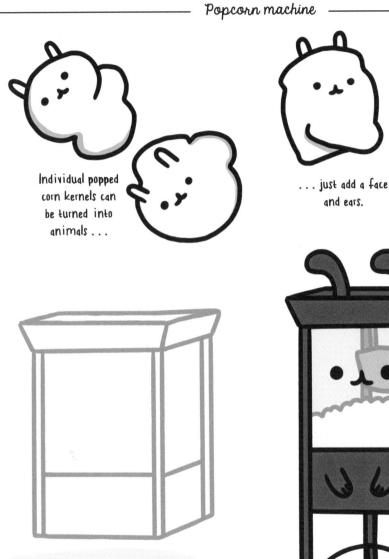

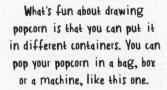

CRISPS AND SNACKS

Crisps

Crisps

Crisps

Perfecto! A bunny crisp.

a curved oval.

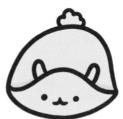

Experiment with complicated shapes to make bent and folded crisps.

- Corn puffs

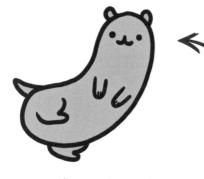

Use the entire corn puff as a face or a body.

Bags of snacks

You can decorate a crisp packet any way you please.

Draw crisps and add some labels to the packet.

Try making the entire bag an animal, like this one.

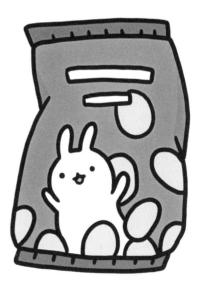

Or the animal can be part of the packaging design.

HOT DOGS

Sausage dog

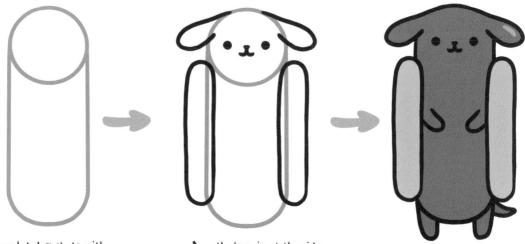

Every hot dog starts with a cylinder. Save the top circle for the face.

Draw the bun in at the sides, as if it's hugging the dog. and add ears and a face.

Add legs and a tail for a comfy, chilled-out hot dog!

Frankfurter

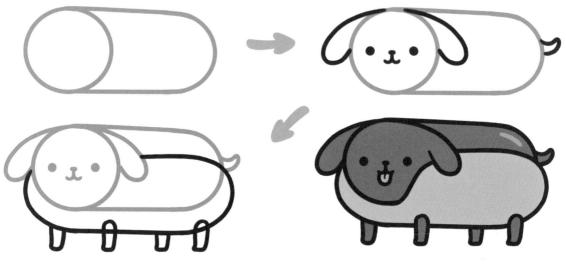

In this version the hot dog is on all four legs. Instead of drawing a vertical cylinder, draw a horizontal one.

The little legs stick out from the bun, so that this hot dog can run and play.

Different dogs

You can start with one base but end up with two different kinds of drawings.

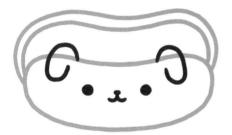

Add a face and ears to the bun.

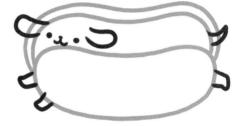

This hot dog's face and limbs are on the sausage. Make the legs and ears stick out so it looks like it's running.

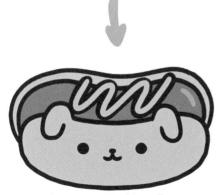

Add some sauce, like yellow mustard, for a tasty look.

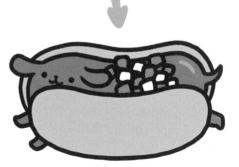

Add some relish to finish the look.

TORTILLA CHIPS

Jortilla shell

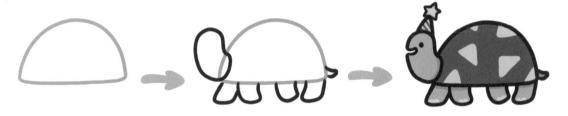

Start by drawing the turtle's shell: it's like cutting a circle in half.

Add the head, legs and a little tail.

Pop a hat on and decorate the shell with a repeating tortilla-chip pattern.

Nacho chip

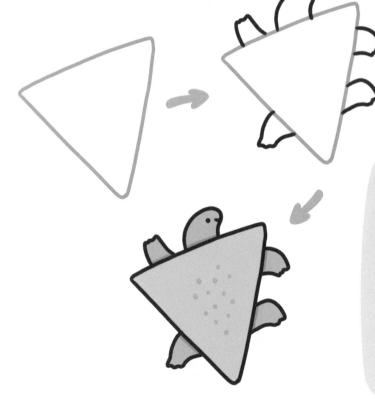

My formula for drawing any turtle is to start with the shell. This time, it's a nacho-chip triangle. Once you have added the head and limbs, the final step is to fill in the features and colours.

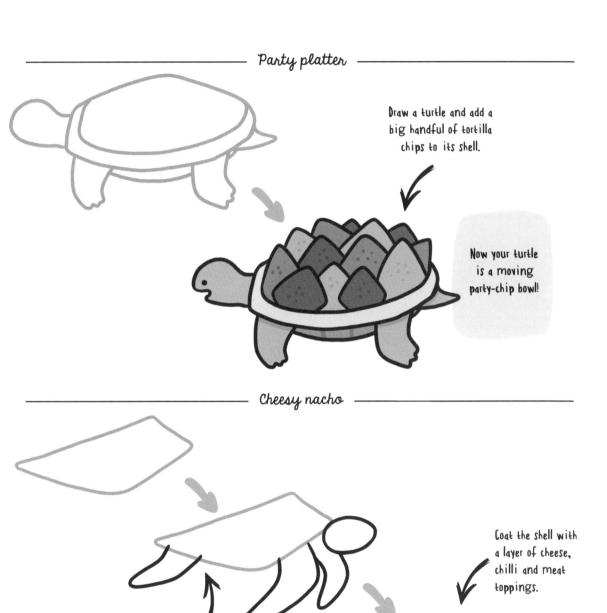

Sea turtles have slim, curved limbs. Their shells are already the perfect nacho shape.

Jortilla chips 27

STEAMED BUNS

animal buns

Start the bun with an oval shape.

If you want to, add the folds that hold the bun together on the top.

The last step is the cute face!

You can give your buns different faces and ears to make different animals. but the oval base will always be the same.

Double-fold bun

You know the drill: start with an oval.

This time, add folds on two sides to look like ears.

I like to add whiskers to my buns. This cat is so cute!

Burs in the steamer

Give your buns little bamboo homes. Draw the basic shape of a bamboo steamer.

Now add the oval shapes for the buns.

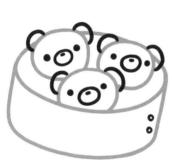

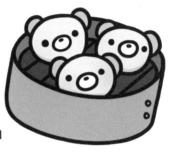

Check out how I added crease lines to the bun where the chopsticks pinch it. Ouch! It really looks like the soft bun is being pulled.

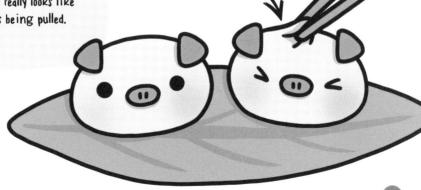

BREAD

Bruschetta

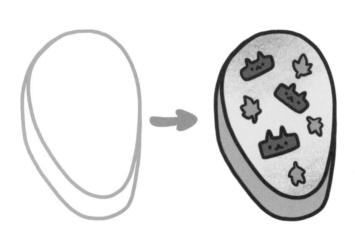

Bruschetta is like garlic bread but with toppings.

Here's a close-up of the toppings you can add: a cute cat tomato and some garnish.

Jarlic bread

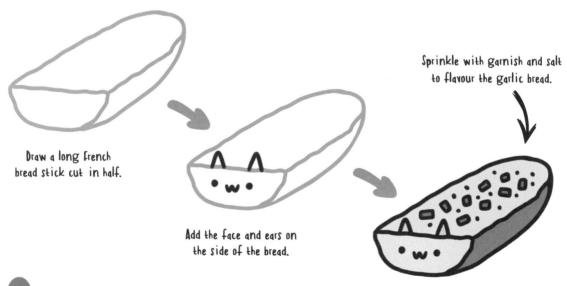

Cubed toppings

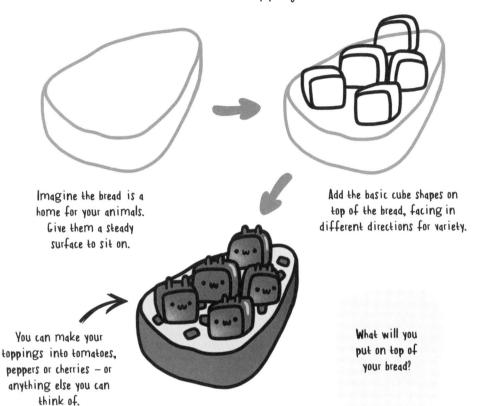

Open sandwich

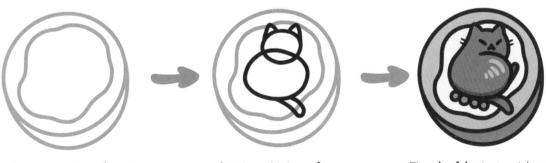

Draw a round base of bread roll and draw a smear of cheese on top.

Add the basic shapes for a napping animal.

The colourful red cat and its green pea cushion stand out against the neutral cheese and bread.

CHEESE SELECTION

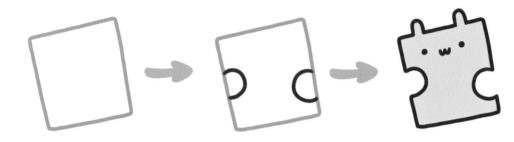

A simple square with holes will look like cheese.

Triangle-shaped cheesy wedges remind me of crocodile heads, so that's what I've drawn!

Challenge yourself to draw many slices of cheese. That's a lot of animal faces!

Instead of a flat slice, you can try to add dimension to your cheese.

Practise making multiple cubes and giving each a different expression.

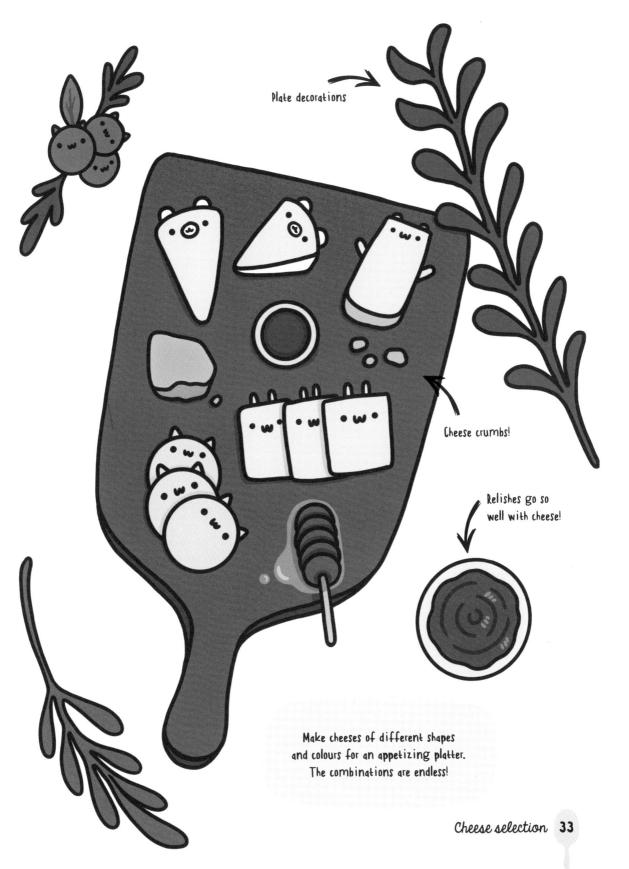

CHIPS AND WEDGES

French fries

Draw a container to hold your French Fries.

Now draw the giraffe fries in the cup. They look like long socks!

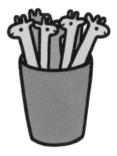

Draw in ears and faces.

To draw a curly fry, outline the base first, then add curved lines for the curls.

Did you know, a group of giraffes is called a tower?

- Bowl of chips

Containers can look like animals, too. Here's a cat bowl.

Get creative with toppings and sauces. Yum! Garlic mayo.

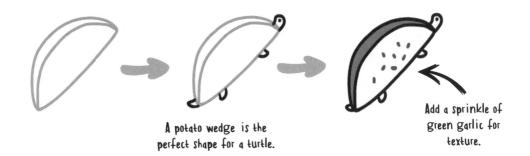

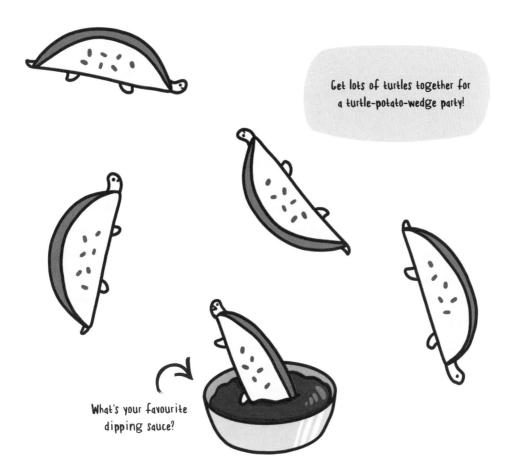

WRAPPED APPETIZERS

Piggy in a blanket

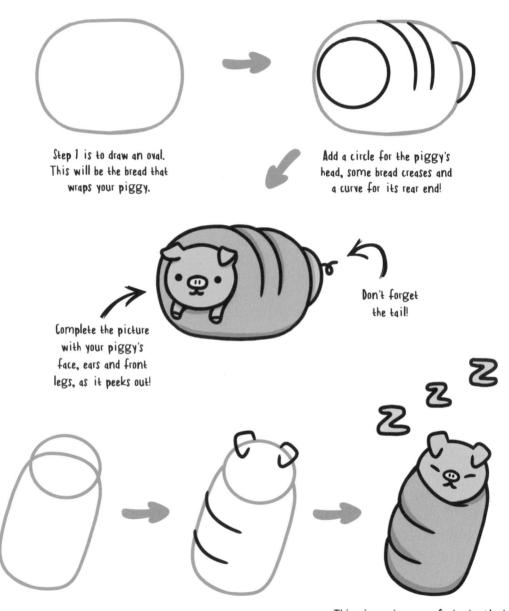

This piggy is so comfy in its blanket it's dozed off. Draw Zs around the pig to show that it's fast asleep.

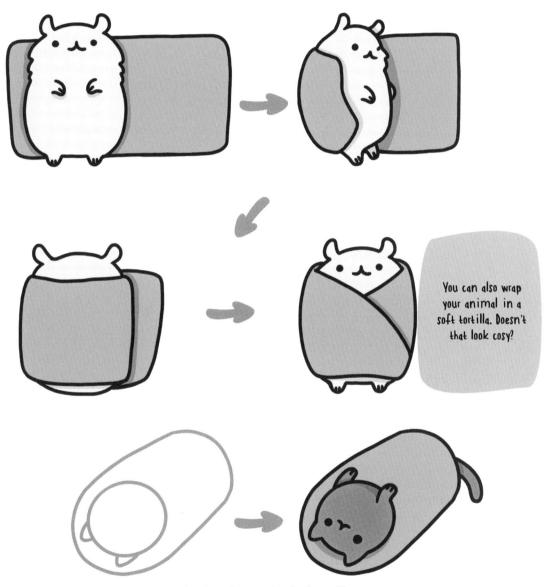

The direction of your animal's face will show how it is wrapped. This pink cat is lying upside down.

SKEWERS

Stacked kebab

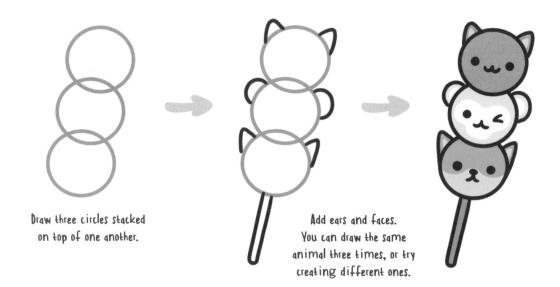

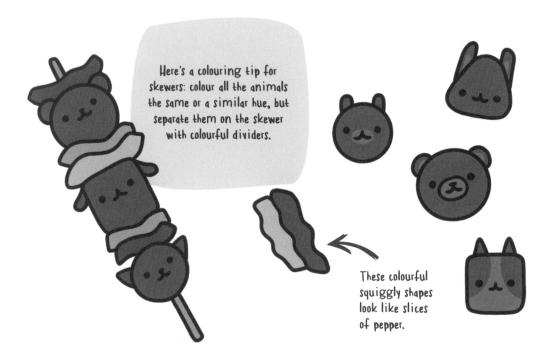

Hugging skewers

Draw a jelly-bean shape for the body of your hugging animal.

Add the ears, limbs and a fluffy tail.

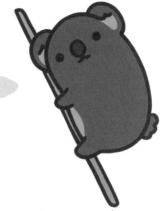

Continue to build the features of your animal. and add in the skewer for it to hug onto.

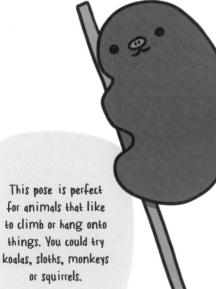

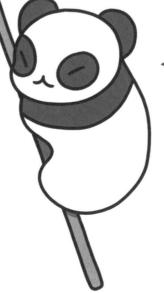

Did you know that adult pandas don't spend much time climbing, but baby pandas love it.

LEAF WRAPPINGS

Leaf roll

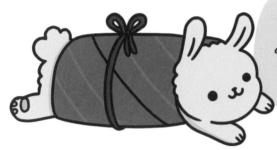

food can be leaf-wrapped to protect the ingredients and also add yummy flavours! This bunny has been rolled up in a leaf blanket.

Iriangle wrap

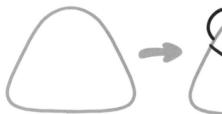

Start with a rounded triangle base.

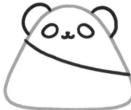

Add a face and ears, and a diagonal line to mark the main part of the leaf.

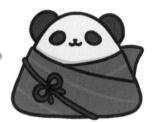

Complete the rest of the leaf wrapping, plus a bow to keep it all together.

Cigar wrap

This time, draw a cylinder.

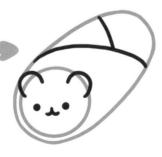

Draw the bear's face and ears in the circle opening and add leaf fold lines.

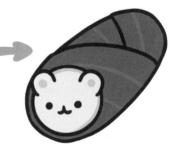

Use a light colour for the bear so it stands out against the dark green leaf.

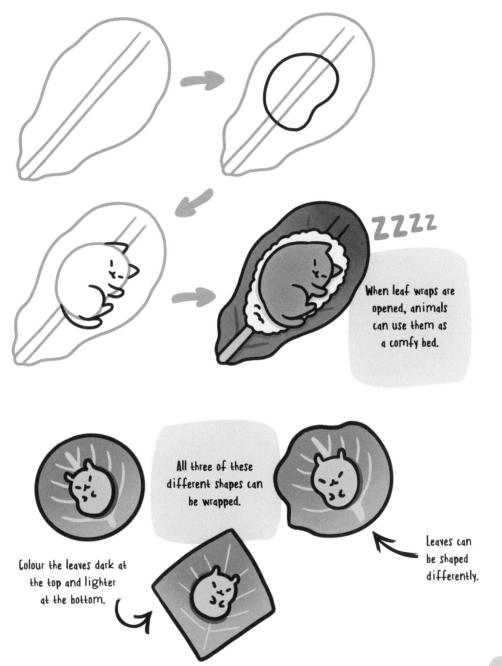

Leaf salad

The base of every salad drawing is the bowl.

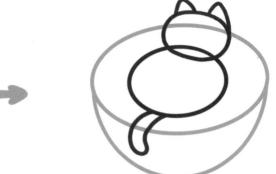

Next, draw in the round shapes of a tiger.

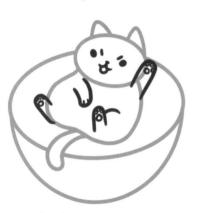

Continue to add in paws and facial features.

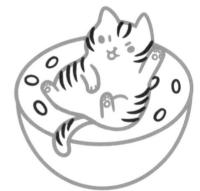

Layer on the stripy tiger patterns and add some tomatoes to the bowl.

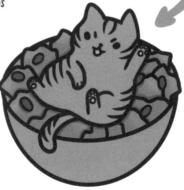

Finish off with the big cat's lettuceleaf bedding.

Mixed salad

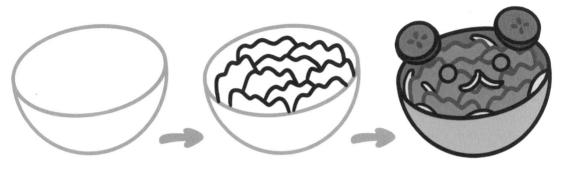

You know the drill: draw your bowl!

fill the bowl with leaf textures.

Add ingredients to make an animal face, such as green olive eyes and sliced tomato ears.

Cheese salad

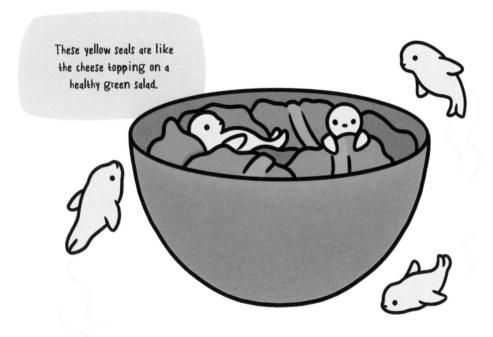

CHOWDER

Cup of soup

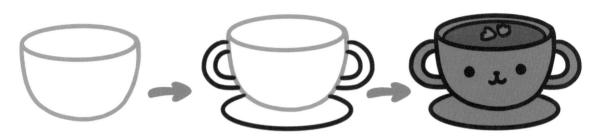

First, draw a cup.

Next, add its features, such as handles and a sturdy base.

Lastly, add the animal face to the cup and some garnish to the chowder.

Chunky chowder

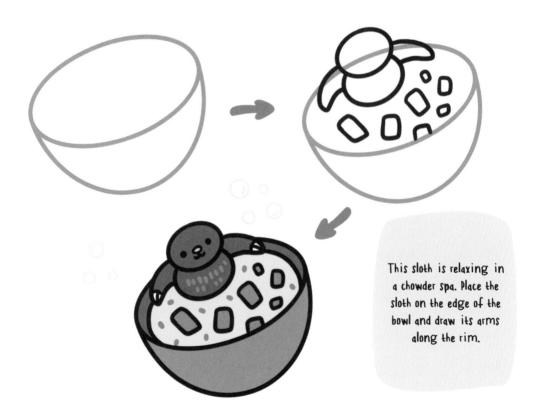

Chowder bowl

Draw a chowder in a bowl and use the ingredients of your choice to make a face.

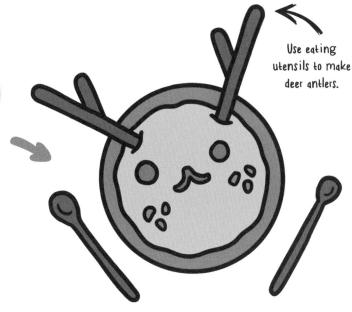

Soupy swimming

Alligators look like green vegetables! A great ingredient in a big bowl of chowder.

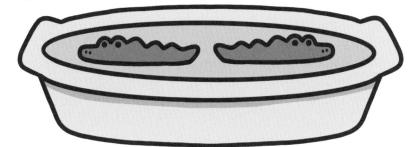

PLATTERS

Sandwich platter

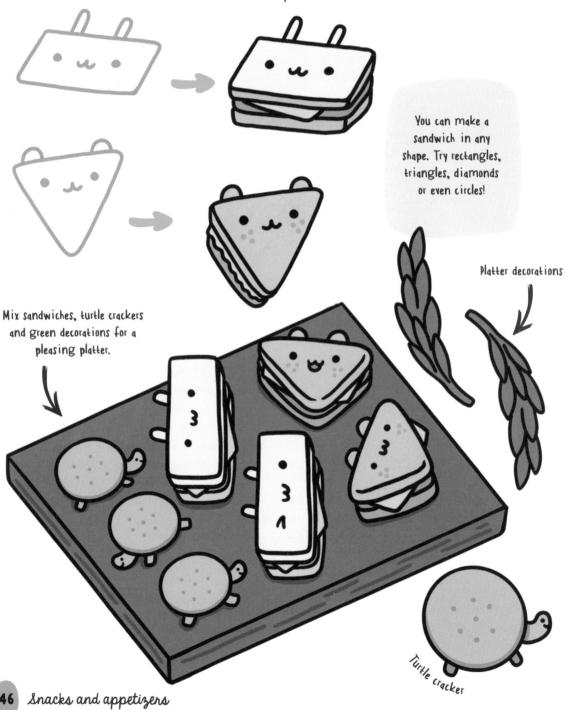

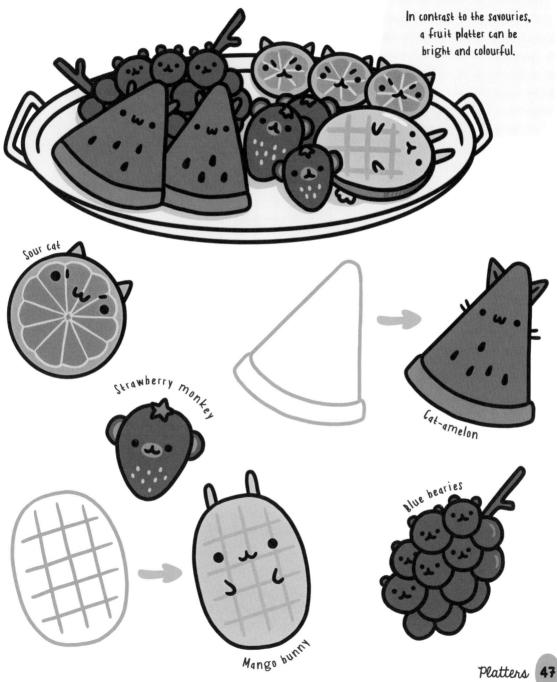

SWEETCORN

Corn on the col

When you peel a corn cob but leave the husk on, the corn looks like it's wearing a dress!

Start with the basic shape of a corn on the cob.

Draw vertical lines down the cob.

Then add horizontal lines to create the corn pattern.

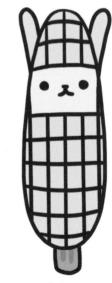

Erase some of the corn squares and draw in a cute face. Add ears at the side to make a corn bunny.

Corn bread

Corn bread is a block of cuteness!

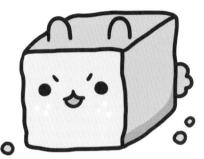

It is typically crumbly, so add little crumbs around your corn-bread animal.

Corn kernels

Corn kernels can be drawn as loose, individual pieces, each one with its own little face.

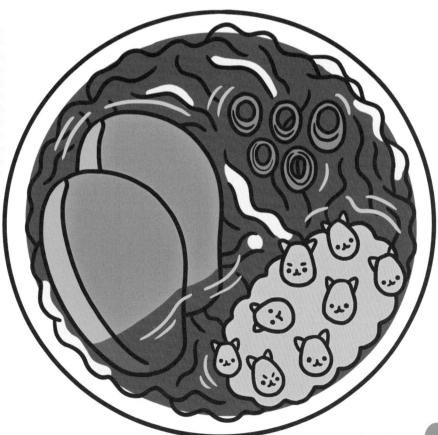

Sweetcorn

STUFFED VEGETABLES

Peppers

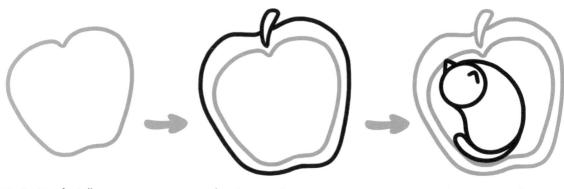

The inside of a bell pepper resembles a heart.

Add the outer rim and stem.

Make the inside of the pepper into a cosy bed for a napping animal.

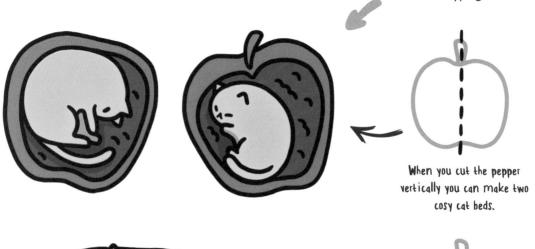

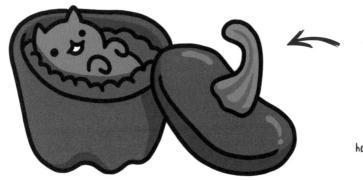

When you cut the pepper horizontally there's more room in the bed for your animal to roll around.

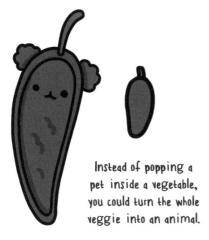

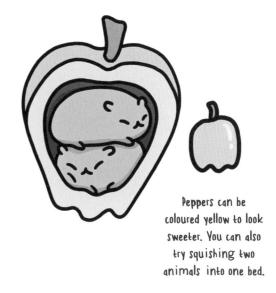

Experiment with different vegetables, colours and animals. This russet fox is curled up and comfy in an orange squash.

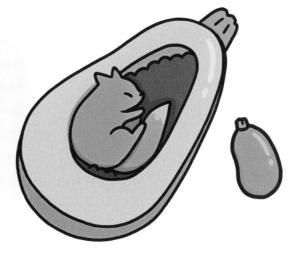

What could be cuter than a red panda asleep on your noodles, or a bunny bun for a burger? There are lots of other ideas to try for cute creature creations.

HAMBURGERS

Cheeseburger

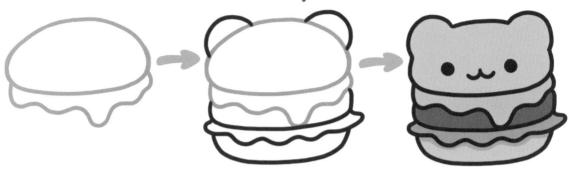

Start at the top of the hamburger by drawing a bun and some cheese.

Pop some round ears on top of the bun, then work your way down, adding the burger, lettuce and the bottom bun. Draw in the animal face and colour the hamburger.

The top bun can be used to illustrate any kind of animal. The trick is how you draw the ears. Try ears that point up or droop down.

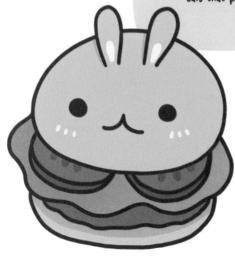

Burger toppings This time, add legs and a tail to the top bun, as well as a face and ears. Draw the rest of the burger as if your animal is lying on top of it! Eggs are a delicious burger topping, and they are cute and easy to draw, too. Burger sandwich

The body of an animal can be used as the entire burger, too!

Curry and rice

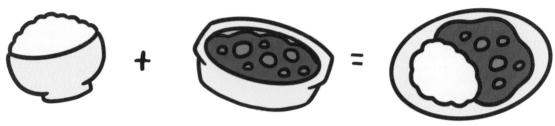

Get creative with curry!
The two components you need are rice and curry sauce.

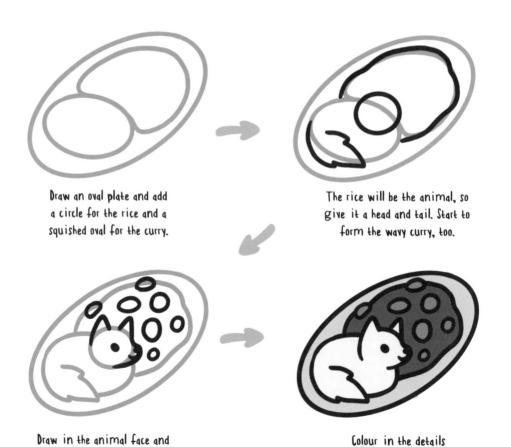

to finish the curry and rice meal.

add veggies to the curry.

The rice can be drawn into many animals, like a family of bunnies.

Bread pairs well with curry Squce, too.

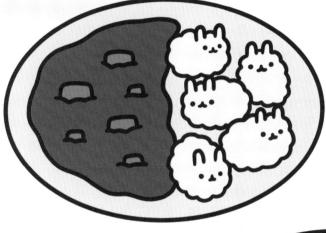

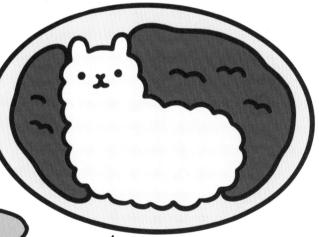

I like paguettes, but you can draw your favourite type of bread.

Rice can also be drawn into one statement animal, like this alpaca.

STONE POTS

Mixed pot

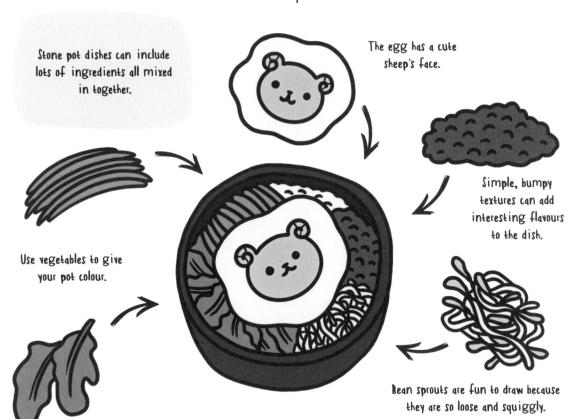

Eggy rice

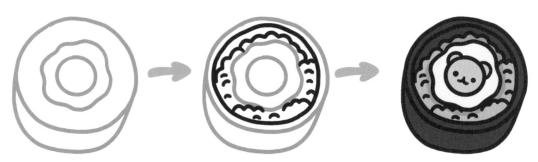

Start this drawing with the pot and an egg.

Draw rice around the egg.

Give the yolk a bear's face and colour in the drawing.

Soupy pot

The base of every stone pot is the pot, of course.

Add a bottom line for the plate that will hold the pot. The semicircle is the start of an animal.

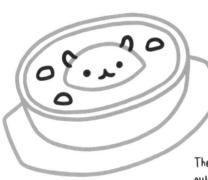

The animal is peeking out of a soup! Add some other ingredients, too.

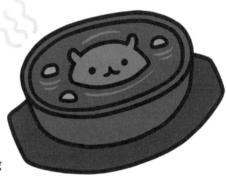

Steamy pot

Don't forget that you can also draw a face on your pot. This pot likes to let off steam!

PASTA

Pasta shapes

This tube-shaped pasta is called penne.

Farfalle is the name for pasta in the shape of a bow.

Pasta shells kind of look like jellyfish.

The frilled edges of ravioli look like a lion's zigzag mane.

Draw a pride of ravioli lions in a pasta-pot den!

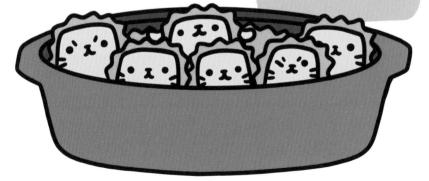

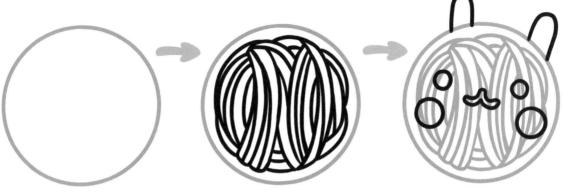

This drawing is about using toppings to make faces. Start with a bowl of spaghetti.

Here's my pasta animal! Try your own version with different types of toppings.

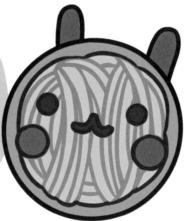

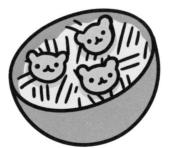

You could also try making cute creature toppings.

TACOS AND BURRITOS

animal filling

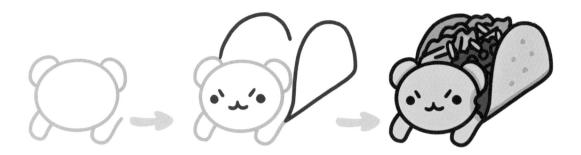

Start with the head and paws of your animal...

... then add the taco shell so that the animal is lying inside it. Give your animal a face, too. Add your choice of foody toppings and fillings.

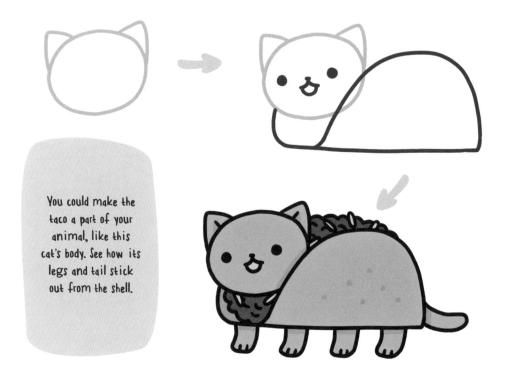

animal shell

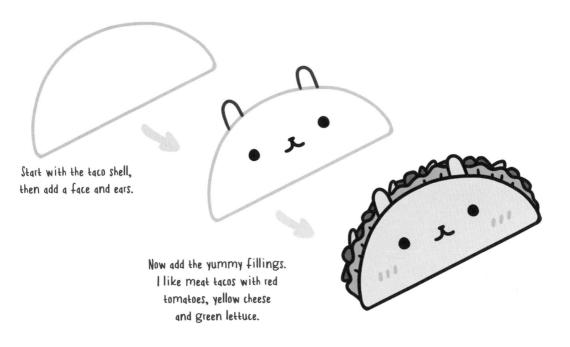

Burrito wraps

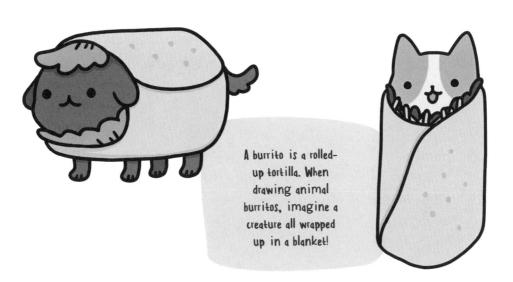

Rice balls

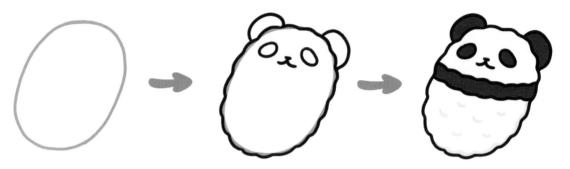

Start with an oval as the base of your rice ball.

Draw bumpy lines around the base for the rice texture, and add ears and facial features.

Draw seaweed around the rice ball to make it look even more like a panda, and add colour.

Try different patterns and shapes for the seaweed to create a family of pandas. They all start with the same base.

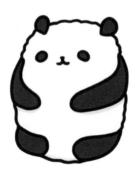

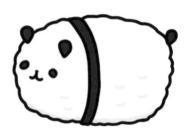

Onigiri

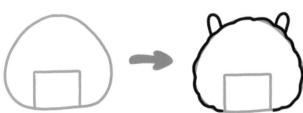

Onigiri is a Japanese-style rice ball shaped like a triangle and wrapped in seaweed.

Like the balls above, draw a bumpy line around the base shape. Add ears.

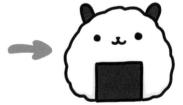

Add a face and colour the seaweed and ears. I've made a bunny onigiri.

Rolled rice

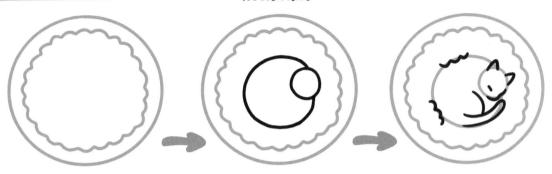

The base of rolled rice is a wavy circle.

Add more circles in the centre to start making a cat.

Add the details. More bumpy lines make it look like the cat is snuggled down in its cosy rice bed.

Pick a cute light colour to fill in your cat; here are orange and pink examples.

Lunch box

Draw an assorted lunch box with a rice face and some vegetables for colour!

SOUPS

Swimming soups

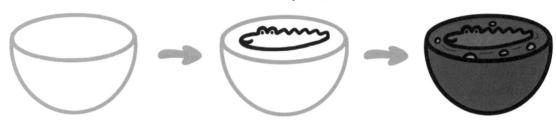

A soup is a great place for swimming animals to hang out, like this alligator.

Let's draw ducks in a soup! Their body shapes are like little raindrops.

Add their heads, beaks and wings.

Finish with a sprinkling of garnish over the soupy duck pond.

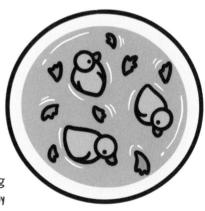

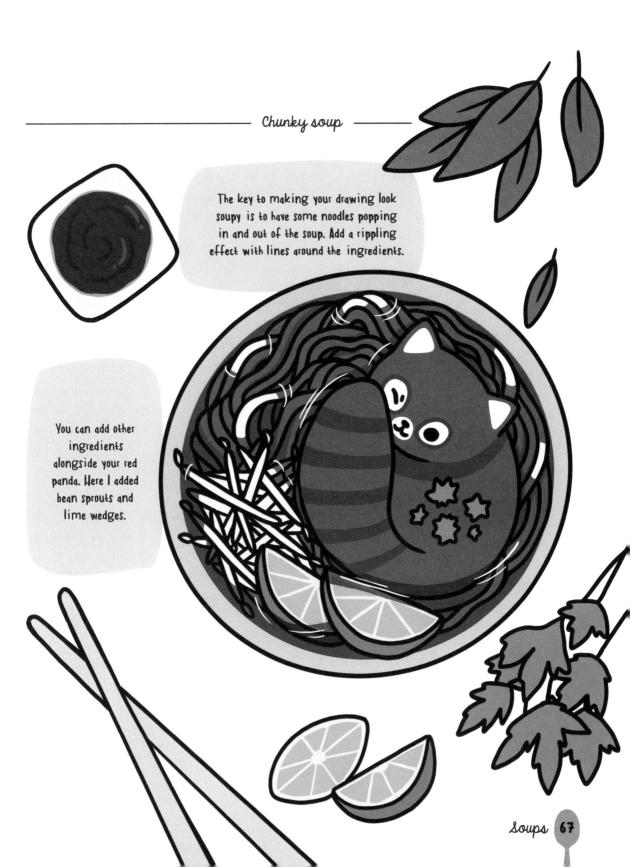

FINE DINING

Sauces

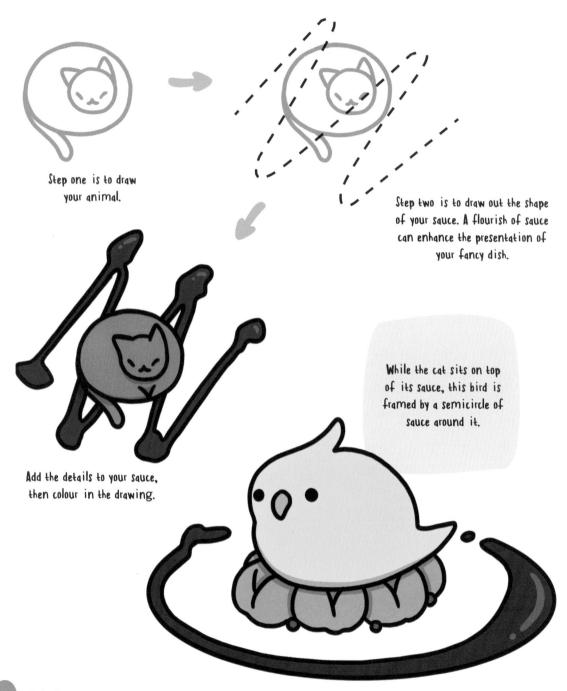

Jarnishes

Start by drawing your animal food.

A garnish is an extra piece of food decoration on the plate, such as a sprig of herbs or a swirl of sauce.

These morsels are garnished with a combination of herbs and surrounding sauce.

Simplicity

SANDWICHES

Baguette

A baguette is a long piece of bread, so start by drawing an oval.

Draw the baguette fillings underneath the oval.

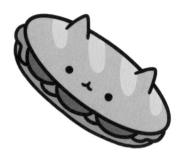

Add a partial oval under the fillings, then add the animal's face and ears to the top of the baguette.

Jea sandwich

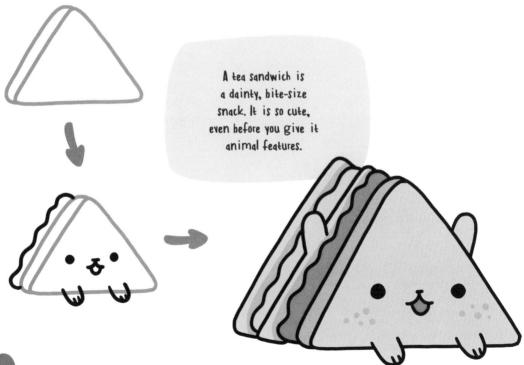

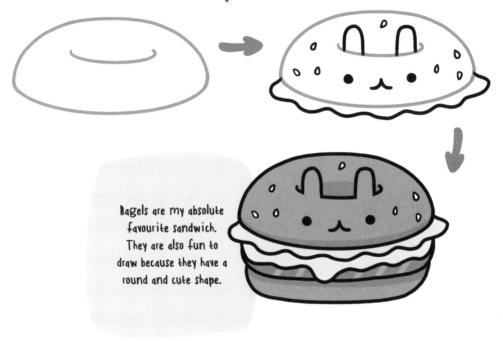

Sandwich filling

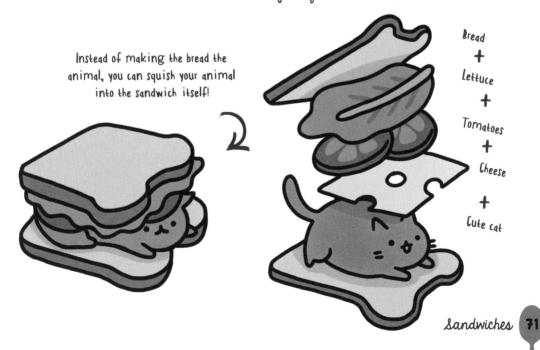

HOTPOTS

Half pot

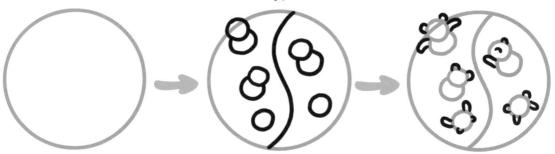

The base of any pot is a circle. Make it a big one so lots of animals can swim in it.

Divide the circle in half so you can have two different broths in one pot. The swimming animals begin life as smaller circles.

Add the details, like ears and legs.

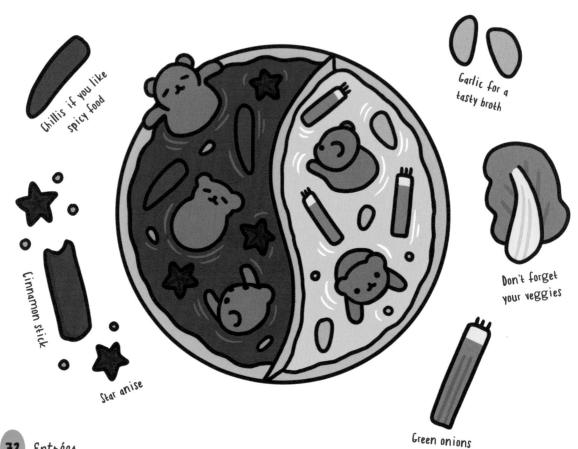

Square pot

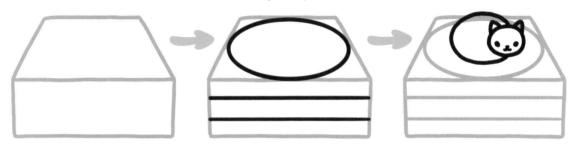

Small square pots are great for one animal.

Add a circle in the centre and lines across the front.

Draw your animal inside the circle.

Cabbage

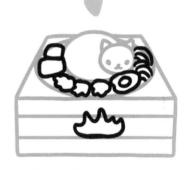

Add the fire that heats the pot under the cat, then add all the food. Maybe cabbage, tofu, eggs and noodles.

To make your fire really come to life, colour the rim and lines of the pot surrounding the flames with yellow, so it looks like the fire is lighting up that whole area.

EGGS

Hard-boiled egg

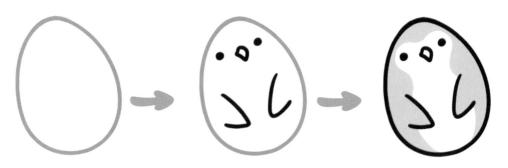

A hard-boiled egg can be made into any round animal. This one is a penguin.

Eggs Benedict

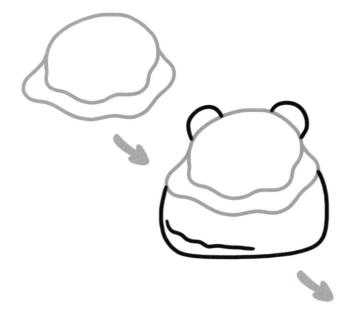

This breakfast favourite features oozy eggs on top of baked muffins. The green freckles are tiny pieces of onion garnish.

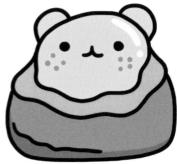

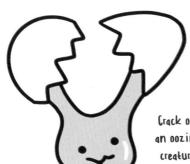

Fried egg

Crack out an oozing creature.

The round yolks of fried eggs make the perfect shape for animal faces.

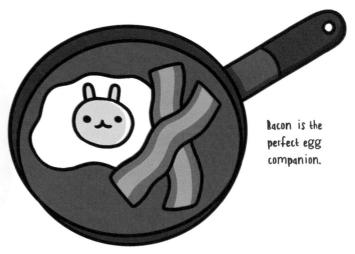

Omelette

An omelette is made using whisked-up eggs. This dish is less oozy, so the shape can be drawn with straight lines.

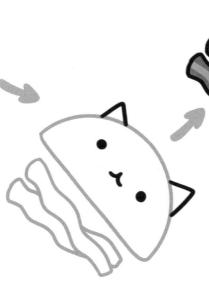

Draw a face in the middle part of the omelette and add ears on top.

NOODLES

noodle bowls

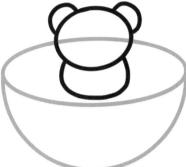

Start with the bowl and bear — or other animal!

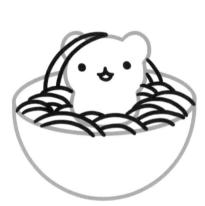

Draw the noodles around and over your cute creature.

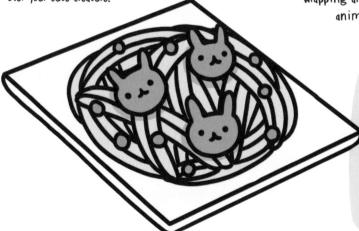

These bunnies represent carrots. Colours can help distinguish what kind of food you are drawing.

Noodle toppings

The size of your bowl will determine how many ingredients you can fit into it.

Give wavy noodles a try! Repeat this pattern to fill the bowl.

Add a bunny egg on top of your noodles.

The choice of toppings for your noodle bowls is endless! Here's a dish I enjoy: it has cucumber slices, basil leaves and grated carrots - oh, and a sleeping cat, of course!

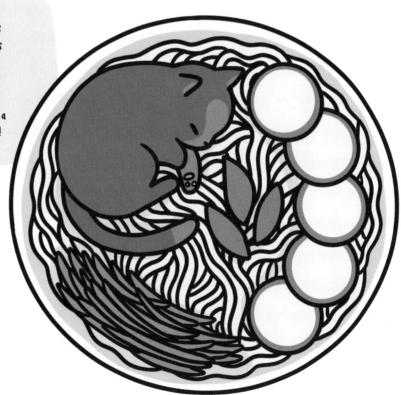

Egg on toast

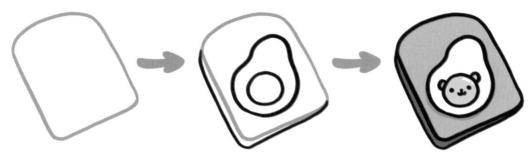

Draw the toast base and circular shapes for the egg. Add ears and a face to the yolk for a cute animal egg-on-toast meal.

Pancakes

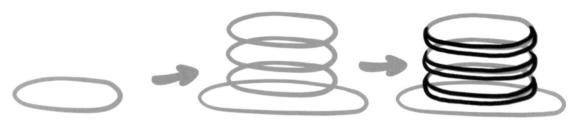

Draw an ellipse for the plate.

Add more ellipses on top of the plate. These are the pancakes.

Draw an extra line underneath each pancake to make them thick and juicy.

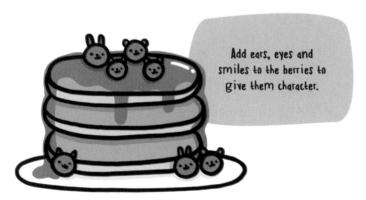

Add circles on top of the pancakes; these are your fruity animals.

Porridge

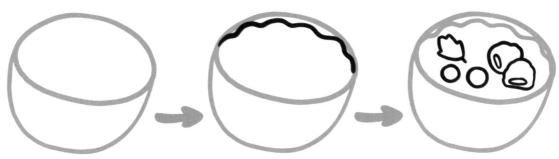

The starting point of a porridge drawing is the bowl.

Add a bumpy line for the porridge before adding fruity animal toppings.

You can pick your own fruit. My favourites are blueberries and raspberries.

Breakfast crepe

I like to think of crepes as a triangle bed.

Add circles with ears to the top of the bed (these are the animals' heads).

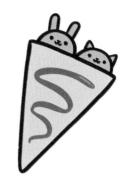

Finish with the details and decorate your crepe with chocolate sauce. Look at those cute cuddling animals!

SUSHI

Seaweed wraps

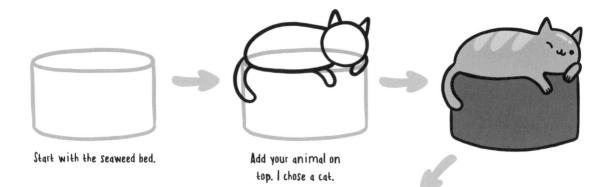

You can also wrap your animal in seaweed. Start by drawing two ovals: the top will be the animal and the bottom will be the rice.

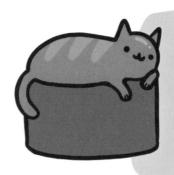

Colour and draw your cat based on which kind of sushi you like. I referenced a shrimp to draw this cat!

Add a rectangle for the seaweed wrap.

Now imagine how your animal will lie.

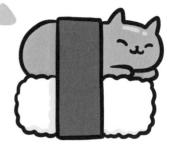

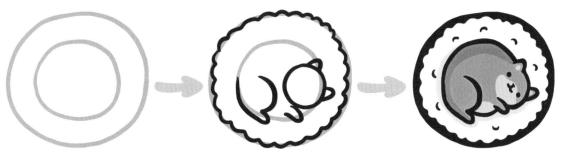

The key to most sushi drawings is starting with round shapes such as circles and cylinders.

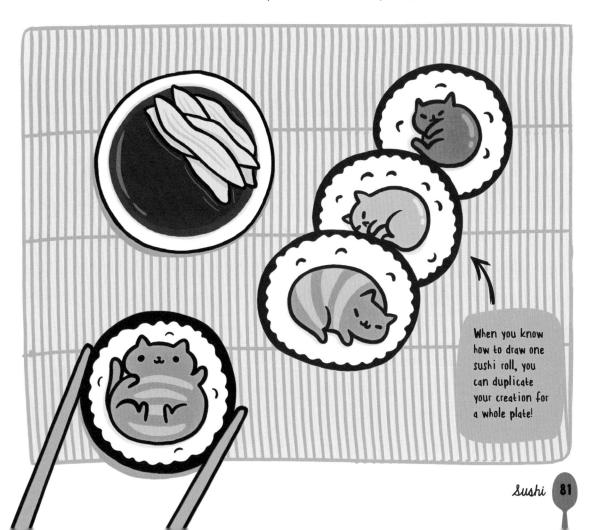

Pizza slice

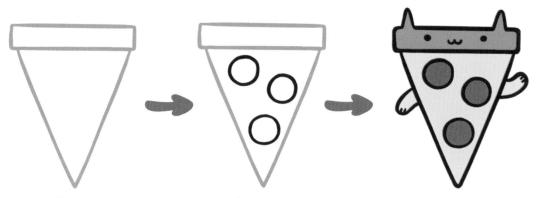

The base of a pizza slice can be a simple triangle with a rectangle on top for the crust.

Add circles for the toppings.

Create your animal by giving the pizza crust a face and ears. You can also add some limbs.

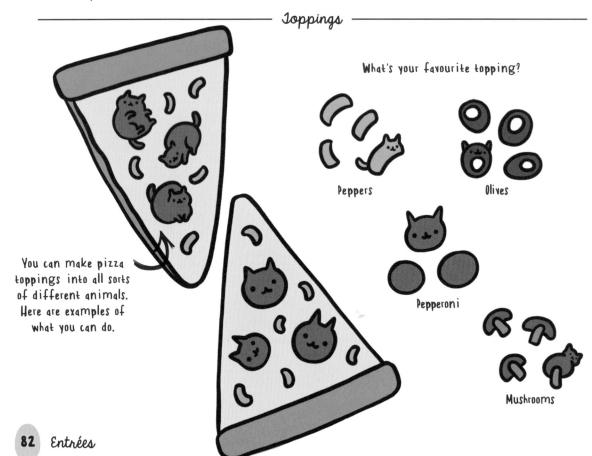

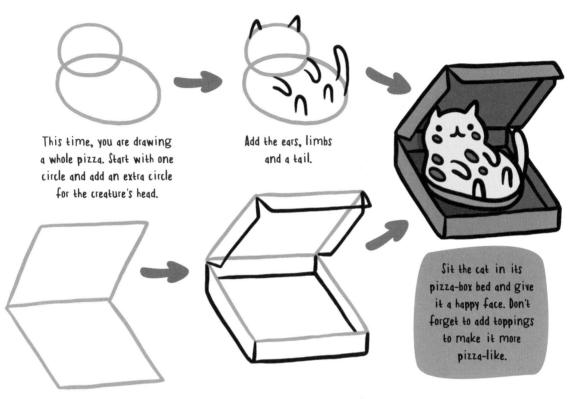

Here's a simple way to draw a pizza box.

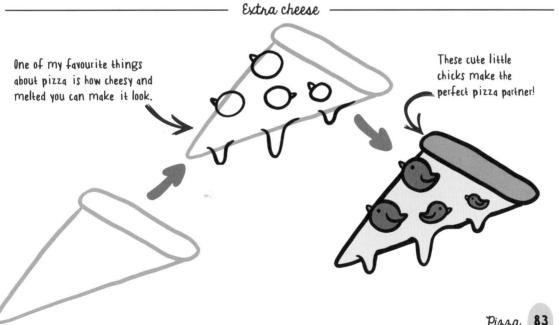

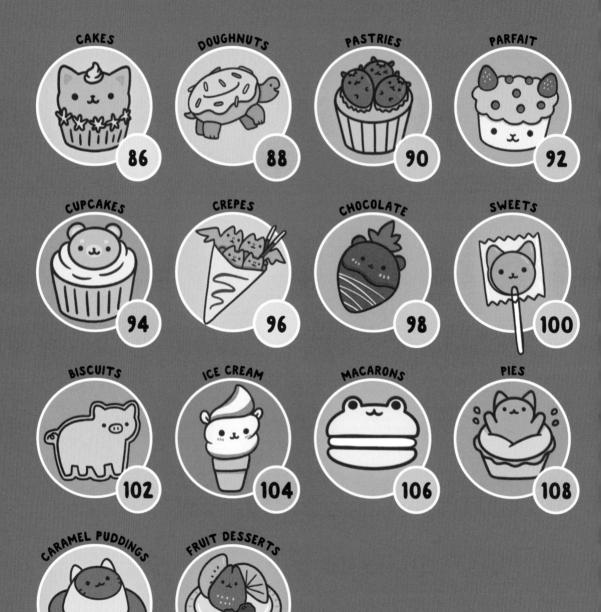

AND SWEET TREATS

The animals in this chapter love their sweet treats, whether that's cookies, cakes or crepes.

CAKES

Swiss roll

This is a rolled-up turtle cake! Start with a cylinder on its side.

Draw the swirls on the cylinder that make the cake look rolled up. Then add the turtle's head and legs.

Add some colour and flavour to your cake. Green reminds me of matcha, kiwi or watermelon.

Fruity toppings

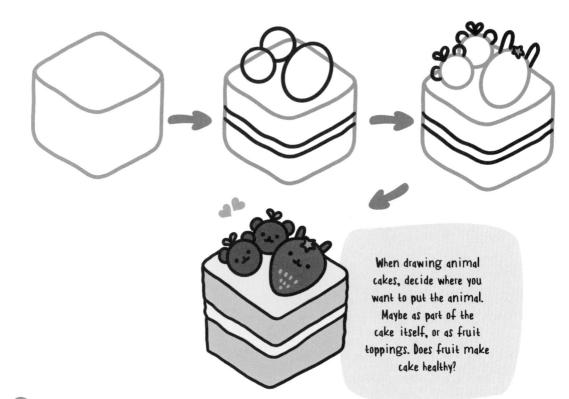

Use bright colours to make your cakes pop. The colours of the cakes and toppings also show what kind of flavour they are.

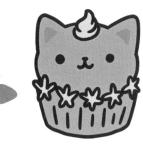

This fancy little cake has a simple base of an oval and rectangle.

Draw in the cat face and ears, then decorate with piped icing patterns.

DOUGHNUTS

Glazed doughnuts

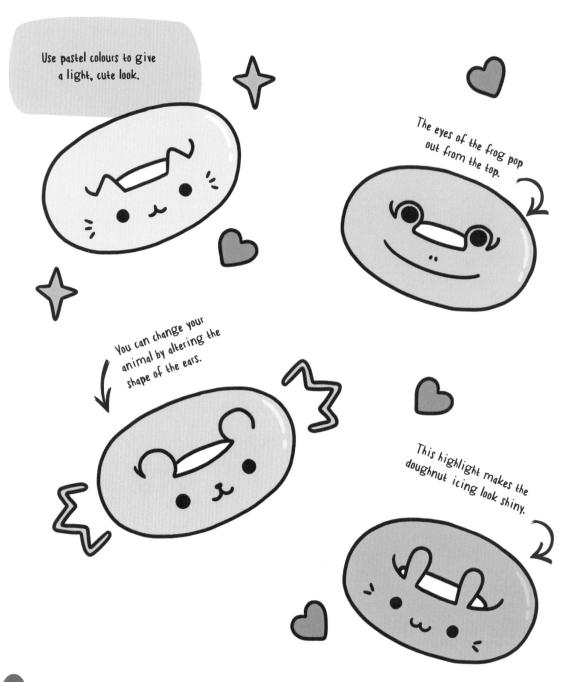

Plain doughnut

The base of every doughnut is a round shape.

Draw ears at the front of the hole.

Add the facial features and colour in the doughnut cat.

Iced doughnuts

The base of this doughnut is two circles.

Add the face and ears of the doughnut animal.

Cover half of the doughnut with icing and add a few sprinkles.

As well as adding a face, you can make a doughnut into a whole animal. Draw little legs and a head to make a turtle doughnut, and top the icing with sprinkles.

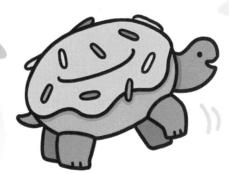

PASTRIES

Pastry roll

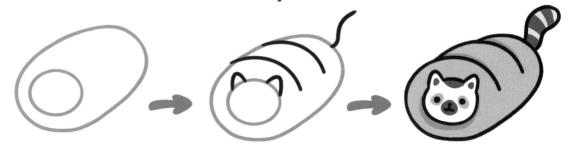

The base of a wrapped pastry is a cylinder. Add a circle where the face will go.

Draw ears, curved lines on the cylinder for the pastry creases, and a wobbly line for the shape of the tail.

Don't forget to colour in the dark shades around the lemur's eyes and nose.

Pastry burs

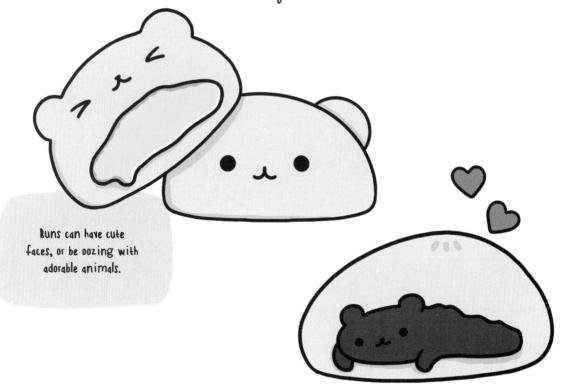

Pinched pastry

Some pastries are pressed closed on the edges, with the fork or finger marks clear to see.

Draw the face of the pastry bunny near the top, so it can look up.

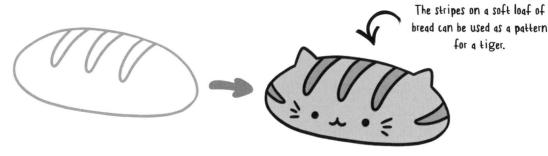

Fruit pastry

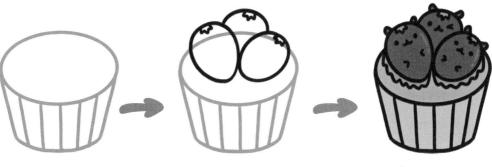

fruit pastries start out like cupcakes.

On top, add three round shapes.

Fill in the shapes with little hedgehogs.

PARFAIT

Strawberry parfait

Begin the base drawing with a container and some circles.

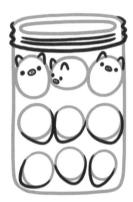

The circles will represent strawberries and little piggies. Add some curved lines for the detail around the top of the jar.

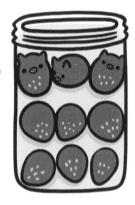

Colour the piggies red and add yellow seeds to each fruit.

Containers

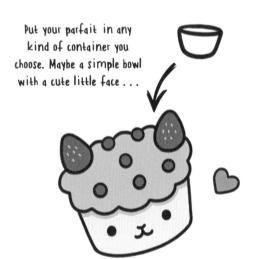

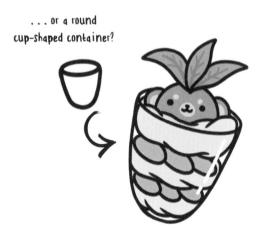

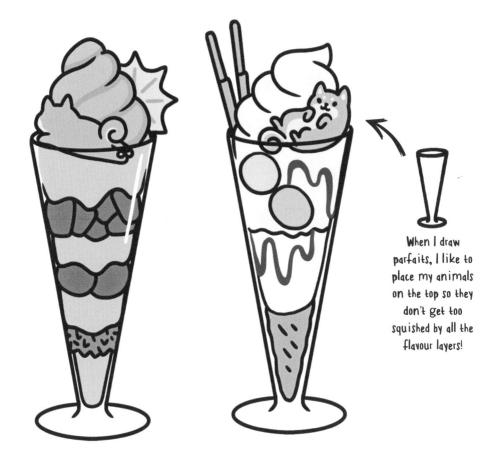

Your parfait layers might include ice cream, fruit, nuts, whipped cream and more. The possibilities are endless!

CUPCAKES

- Fancy cupcake

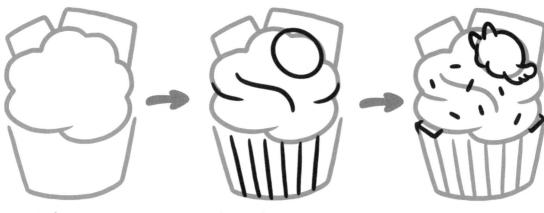

Think of cupcakes as two parts: the icing top and the wrapper bottom.

Add details to the icing and wrapping, and a shape for your animal.

Add sprinkles to the icing and details to the animal.

What's your favourite cupcake flavour? The colours you choose will determine what flavour you've drawn. This one is obviously chocolate!

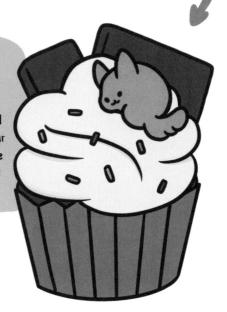

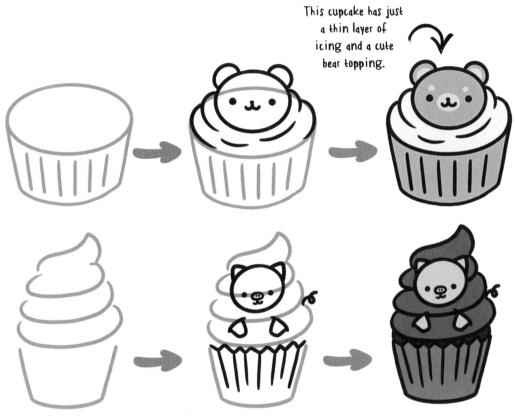

The icing on this cupcake is extra swirly!

Let's add a little piggy buried in the swirl.

The chocolate icing makes the pig look like it's playing in mud.

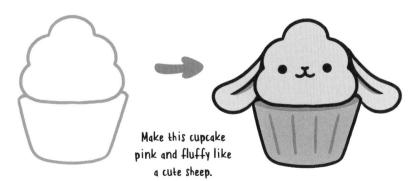

CREPES

Folded crepe

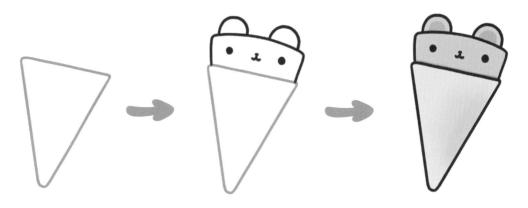

The base of a folded crepe is a triangle.

Draw a bear poking out of the crepe to say hello.

Add a glow of light and dark colours to the crepe to make it look tasty.

Crepe wrap

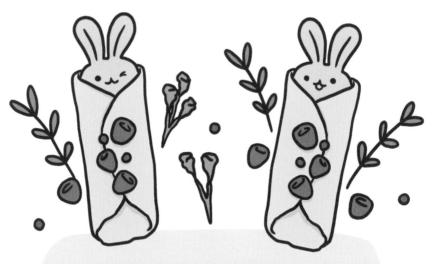

Rolled-up crepes have a cylindrical shape. You can put them on a fancy plate with fruit, flowers and herbs.

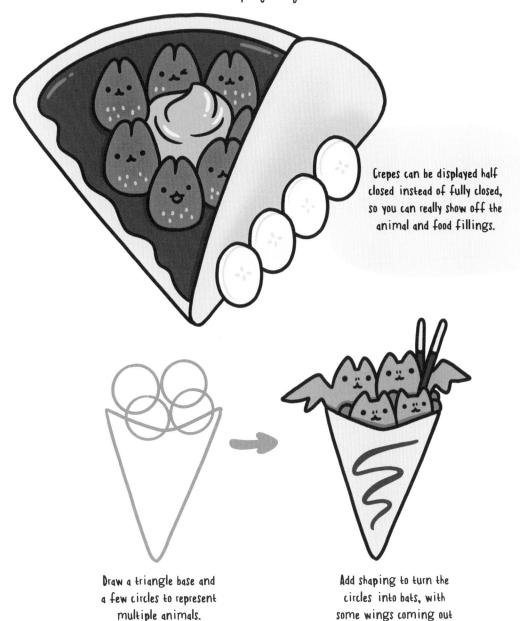

at the sides.

CHOCOLATE

Chocolate bar

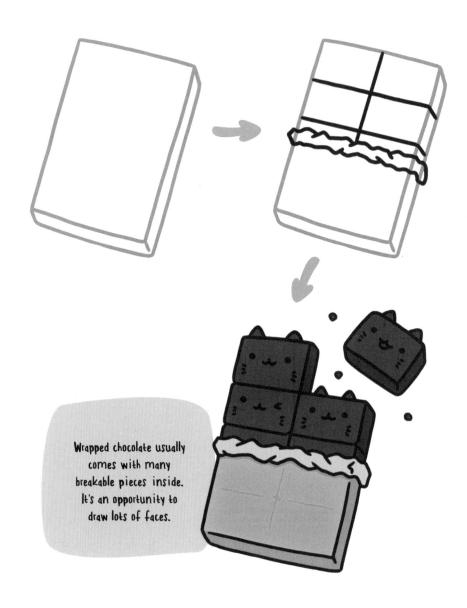

Chocolate pieces

A small piece of chocolate makes a cute little animal.

Draw the face and other features on one side.

Add a shine highlight at the back to make a tempting, scrumptious chocolate piece.

Chocolate animals

Experiment by drawing different chocolate animals. Rounded shapes look good.

Chocolate-dipped strawberry

Start with a basic strawberry shape.

Add a wavy line to indicate a coating of dipped chocolate.

Add zigzags to the chocolate for a fancy effect.

Lollipop

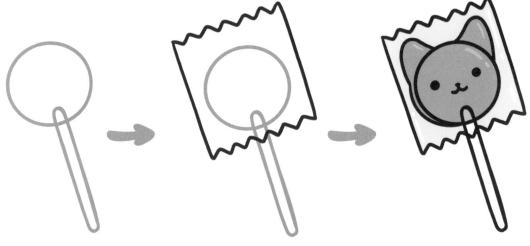

Lollipops start with a circle and a cylinder for the stem.

Draw a wrapper on top of the circle.

Add animal features and finish off with some colour.

Jummy bears

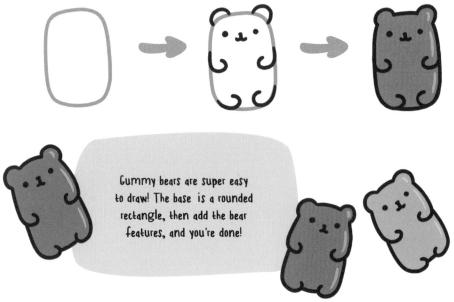

Wrapped sweets

A sweet wrapper has wings, like a bat.

Add lines around the wings to make them look like they're flapping.

Jummy animals

Drop white dots on your gummies to give a sugary effect.

Candyfloss

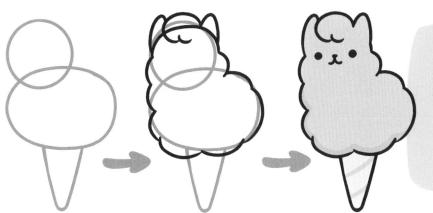

Candyfloss always reminds me of sheep or llamas.

BISCUITS

Iced biscuits

These types of biscuits are a two-step drawing process. Step 1: Draw the animal silhouette. Step 2: Draw the animal details inside the silhouette

The base of the biscuit is the animal silhouette. This one is a chicken.

Draw an inner silhouette. This will be the biscuit icing.

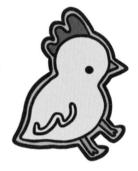

Colour in the icing (inside layer) and then the biscuit (outside layer).

Icing details

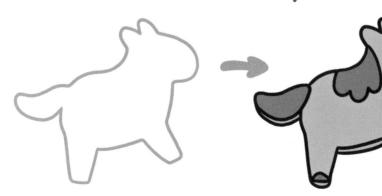

Icing doesn't have to cover the entire biscuit. Here's a horse biscuit with icing only on the mane. tail and hooves.

animal crackers

Darker colours can be used to draw in the biscuit features.

Make your biscuit look 3-D with a blocky effect.

Lion biscuit

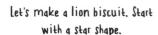

The centre will be the lion's face, and the star is the mane.

Jelly biscuits

Jelly biscuits have fruity animal gels. Add highlight lines to your animals to make them shine like gel.

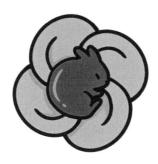

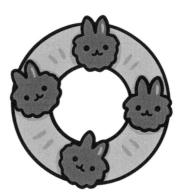

ICE CREAM

Ice-cream cones

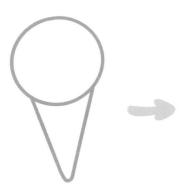

This is a really easy starting point: 4 circle on top of a triangle.

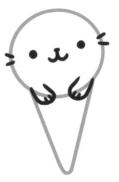

Draw in the animal details. This one is a seal.

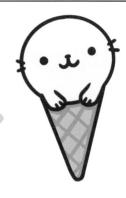

Colour in the seal and the lines for the waffle cone.

Try an ice-cream cone with stacked flavours. Draw multiple circles that overlap slightly.

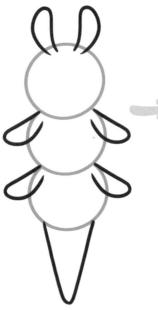

Draw in the cone and animal ears.

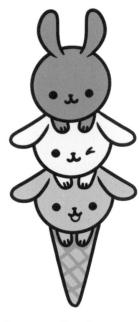

I've made a Neapolitan mix chocolate, vanilla and strawberry.

Ice lolly

Ice lollies are another type of ice cream.

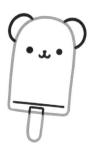

Instead of a cone, an ice lolly has a stick.

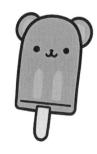

These lollies are perfect for any summer's day!

Soft ice cream

Ice cream with a swirl starts with a circle, but add a shark-fin shape on top.

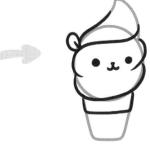

Draw in the swirls around the circle and add the animal features.

This ice cream has swirls of chocolate and vanilla.

Ice-cream sundae

You can also draw your ice cream in a bowl. Make it into a sundae by adding toppings like cherries and bananas.

MACARONS

animal buns

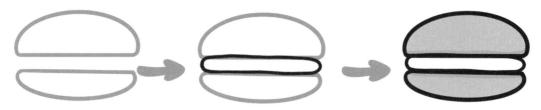

Any macaron can be drawn with these three steps. Step 1: Make the buns.

Step 2: Add the filling to the centre.

Step 3: Colour in the macaron. Now you're ready to add animal faces!

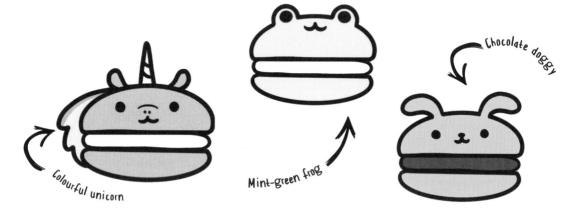

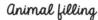

Begin with the top and bottom buns.

The filling is the animal. Add a circle for the head and body, then limbs and a tail.

Add in the details and you've got yourself a doggy macaron.

Macaron animal

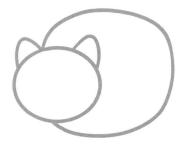

Start this drawing with two circles for the head and body.

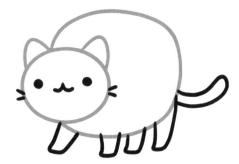

Add on the limbs, tail and face of the cat.

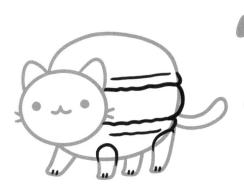

This part is important! Add in the details of the macaron such as the buns and centre filling.

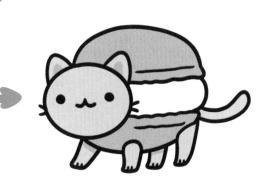

The last step is to colour the cat and buns one colour, then the filling a different colour, or leave this plain.

Macaron tops

You can draw animal faces on the top buns. Draw an extra part-circle around the base to show the bottom bun.

Fruit pies

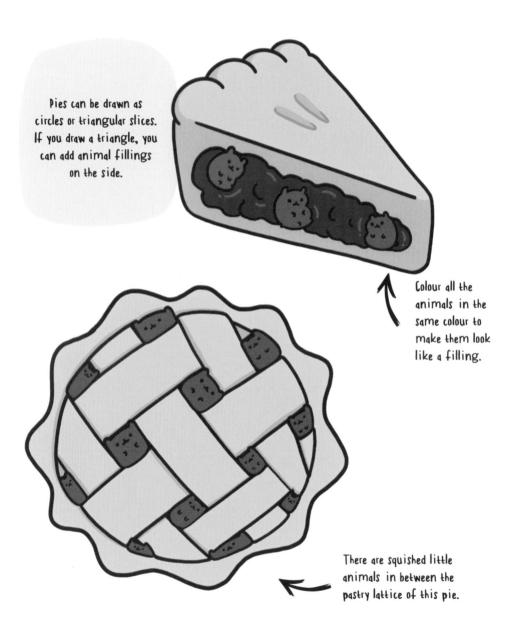

animal topping

The base of this pie is a semicircle and rounded rectangle.

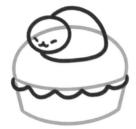

Add a wavy line for the pastry frill and an animal sleeping on top.

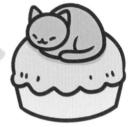

Notice how the cat is a similar shape to the pie. They're both round and cute.

Pasrty animal

Start with a base made of simple lines.

Draw the animal face and ears on your base. Draw a wayy line for the bottom of the pastry.

Here's a dog pie face!

animal filling

So that we can see the whole of the pie top, this time draw a full circle and the wavy pastry line.

An animal can pop out of the centre of the pie.

Draw little bits of pie flying out from the sides to make the drawing really pop.

Caramel dessert

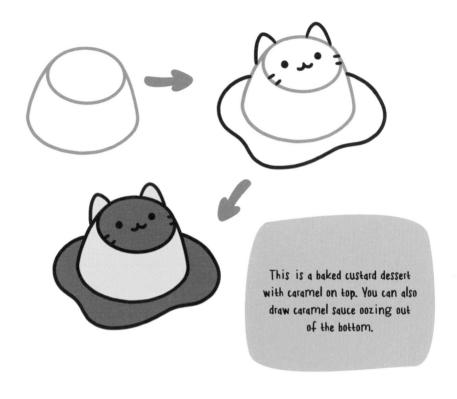

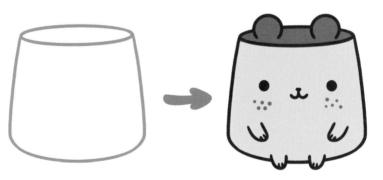

Start the custard base with a fat cylinder.

Instead of on top, try drawing a face and limbs on the custard, and pop on some caramel ears.

gar pudding.

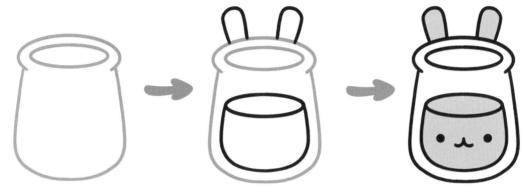

A baked caramel custard can be served on a plate or in a cup or jar.

Instead of adding the ears to the pudding, try adding them to the jar.

What a cute bunny pudding!

Crème brûlée

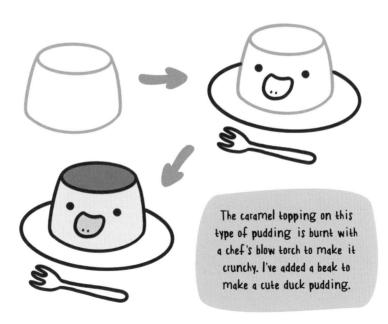

FRUIT DESSERTS

Chocolate-dipped fruit

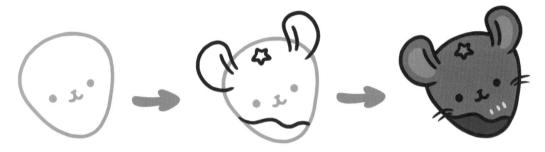

The base of a strawberry is like a round triangle.

Add in details such as the wavy line for the dipped chocolate and oval-shaped mouse ears.

Fruit tart

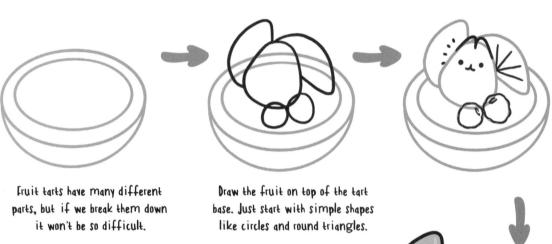

Keep adding details to the fruit and tart to get this final look!

Cats and fruit are floating around this jelly mould. To make your jelly look translucent, use two colours; a light colour around the edge and a darker colour for the inside.

Fruit cake

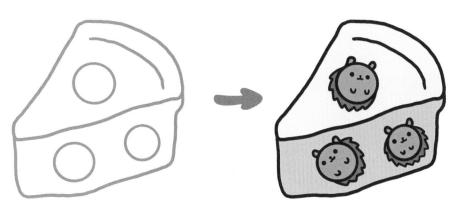

Draw a slice of cake with circles dotted around it.

Turn the circles into round fruit animals: I chose a hedgehog.

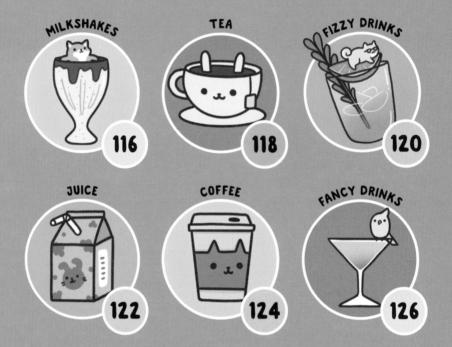

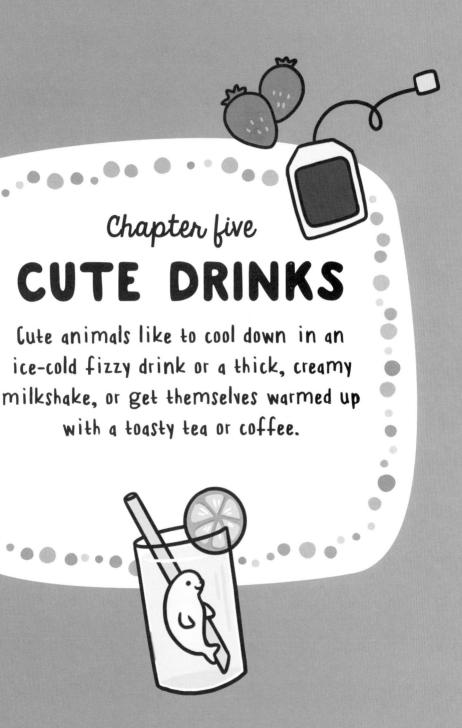

MILKSHAKES

There are various ways to add animals to milkshakes. The animal could be on top, floating inside, or even the cup itself.

Draw a semicircle, then add in the curvy lines on top, for a scoop of ice cream.

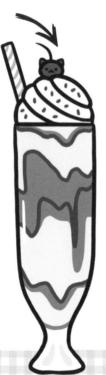

Turn any mug into an animal! Imagine having a mug and then adding the head, limbs and tail.

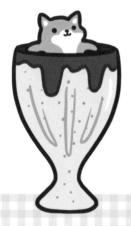

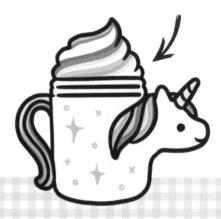

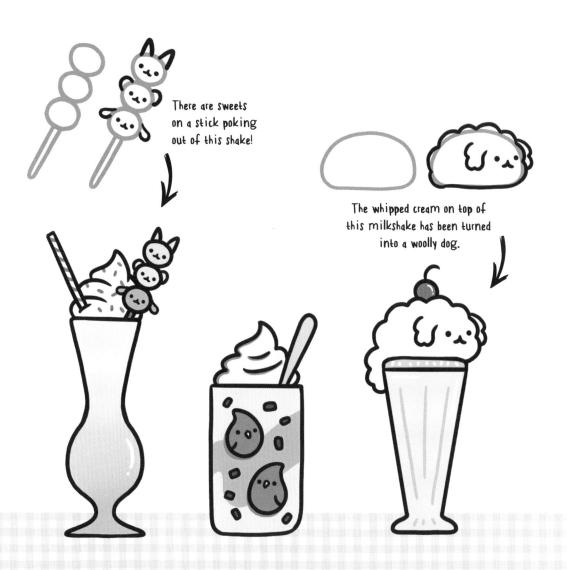

A milkshake is a sweet drink made from milk and ice cream. There are many toppings and syrups that can be added to make an even sweeter flavour and a pretty drink.

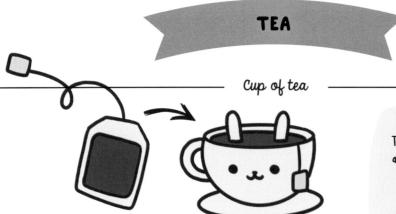

Teabags hold the tea leaves, and can be left in the cup as you drink. Give the cup a face, but add the ears to the tea!

Fancy tea

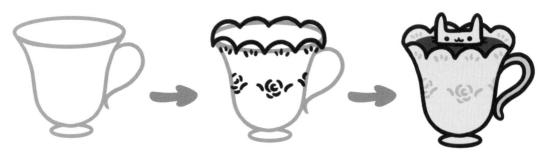

Let's draw a fancy teacup. Remember to make it very curvy. Add in the dainty details, such as floral designs or little curved lines.

The final touch is a little animal relaxing in the warm drink.

Bullle tea

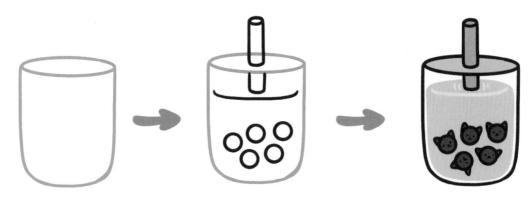

Bubble tea is a combination of milk and tea.

Bubble tea contains chewy additions called boba.

The boba can be given animal features.

Jeapot

Try drawing a teapot and teacup set. Start the pot with a circle.

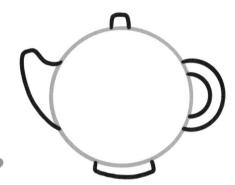

Extend the spout of the pot and add the curved handle and also a supporting base and lid. It's starting to look like an elephant.

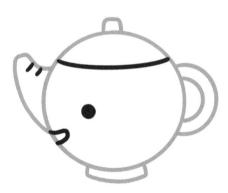

Add the facial features. Now it looks like a happy, cute elephant.

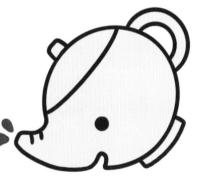

Add a small teacup to pour your hot tea into. Now you have a set.

FIZZY DRINKS

Drinks can -

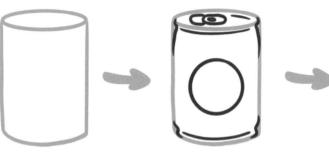

The base for a drinks can is a cylinder.

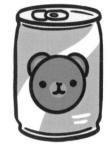

Draw in the design of your can. Make the animal face big and cute in front.

Drinks bottle.

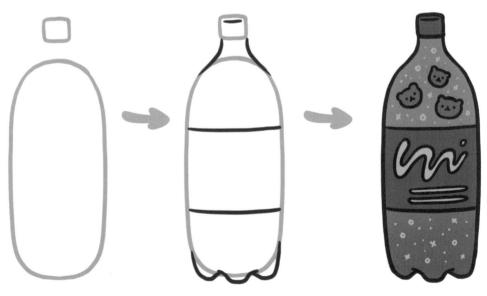

Drinks bottles are also cylindrical.

Draw the details on the bottle, such as the bottom curves that hold up the bottle.

Add in your own bubble motifs and include some happy floating animal faces.

Fizzy drinks can look fancy when you dress them up. Add fruit toppings or garnishes that complement the colours of the drink.

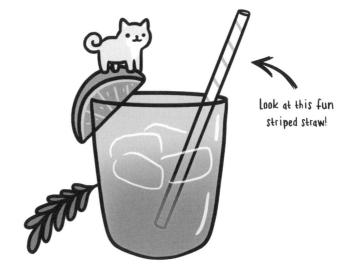

Small animals on the table and around your drinks make your drawing super cute.

JUICE

Juice box

A juice box kind of looks like a small house.

Draw in a bent straw to complete the juice-box look.

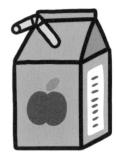

This last part is up to you. What flavour do you want to colour your juice box?

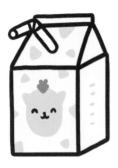

Pineapple cat

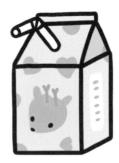

Peach deer

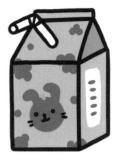

Grape bunny

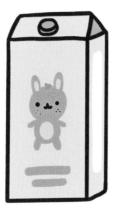

Orange rabbit

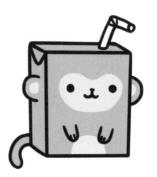

Juice boxes come in many shapes and sizes. You can draw your animal on the box or make the box itself into an animal, like this monkey.

glass of juice

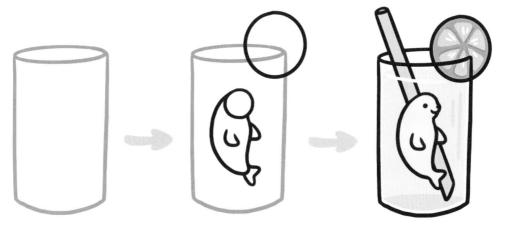

Let's draw our juice in a glass instead of a box.

Draw the base shape of a seal inside the glass. Add a circle to the edge for the fruit decoration.

Colour in your glass of fruit juice. This is a refreshing pineapple juice for a hot day.

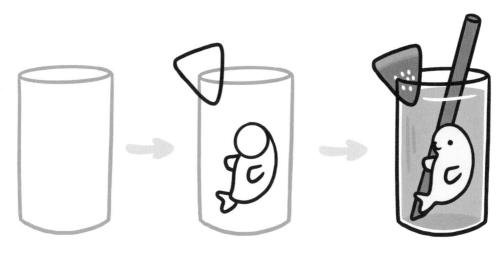

This time, add a triangle on the edge of the glass for a watermelon garnish.

Colour in the drawing with bright pink colours and add the details to the watermelon slice.

COFFEE

Coffee to go

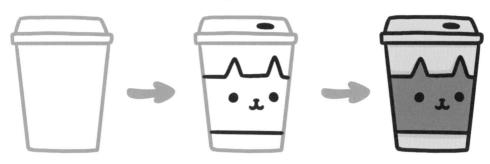

Draw a takeaway coffee cup.

Add a sleeve around the cup. This protects you from the hot contents.

Colour in your cute animal sleeve and coffee cup.

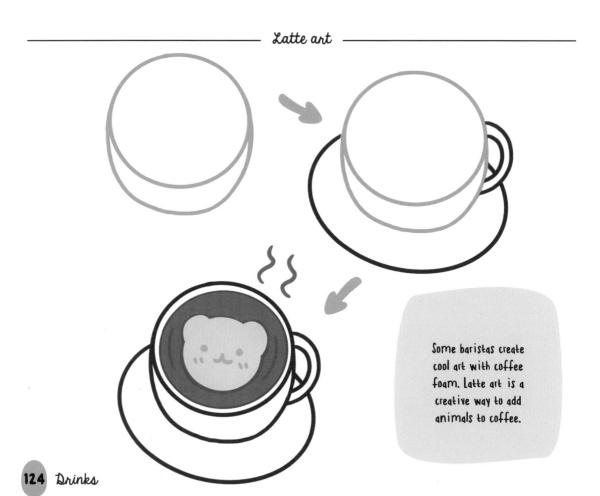

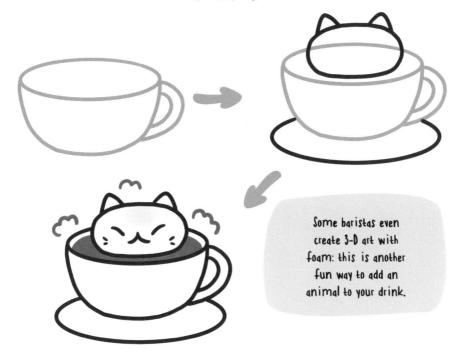

Iced coffee

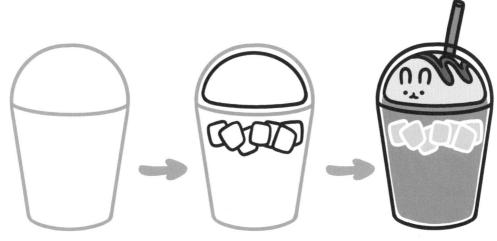

Coffee drinks can be cold, too.

Add ice inside the container and foam on top of the coffee.

Give the foam animal features and add caramel sauce and a straw.

FANCY DRINKS

Fancy glass

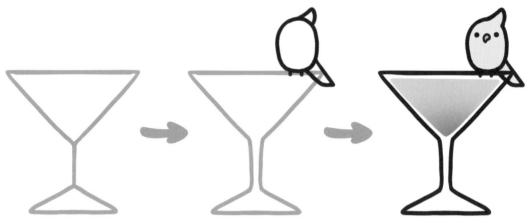

fancy drinks come in fancy glasses. Here's a simple glass made of triangles.

Add a circle to the edge of the glass; this will be your bird.

Colour is very important because it makes your drink pop! Start light at the top and grade down to a darker shade.

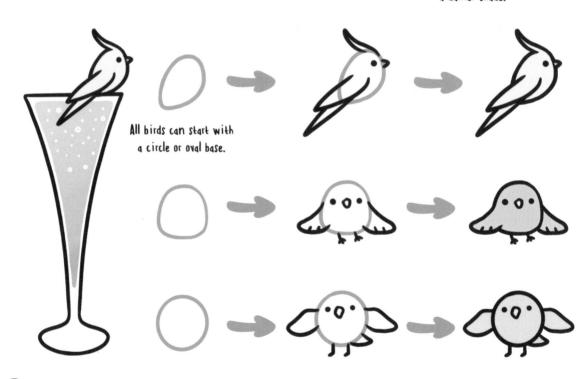

Fancy lemonade

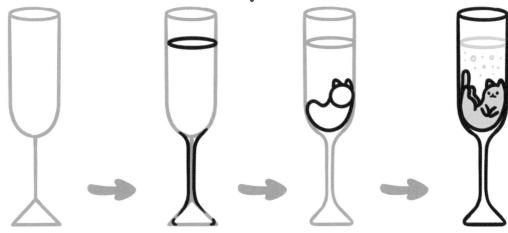

This glass is cylindrical at the top and triangular at the bottom.

a circle and two ovals.

Your animal can be chilling at the bottom of the drink!

Summer special

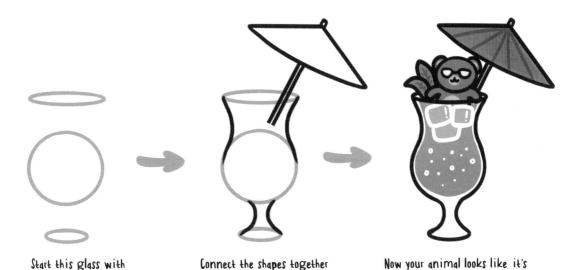

to form the glass. Add a

little parasol to the glass.

relaxing in the shade on a

hot summer's day!

CREDITS

AUTHOR ACKNOWLEDGEMENTS

Kenny, thank you for being by my side when I needed another hand.

PICTURE CREDITS

Quarto would like to thank the following for supplying images for inclusion in this book:

Oliver Hoffmann/Shutterstock.com; nikiteev_konstantin/Shutterstock.com; Sereda Serhii/Shutterstock.com.